A HISTORY *of*

Honey

in GEORGIA
and the CAROLINAS

A HISTORY of Honey

in GEORGIA
and the CAROLINAS

April Aldrich

AMERICAN PALATE

Published by American Palate
A Division of The History Press
Charleston, SC 29403
www.historypress.net

Front cover image by Chrys Rynearson.

First published 2015

Manufactured in the United States

ISBN 978.1.62619.828.9

Library of Congress Control Number: 2015931724

Notice: The information in this book is true and complete to the best of our knowledge. It is offered without guarantee on the part of the author or The History Press. The author and The History Press disclaim all liability in connection with the use of this book.

CONTENTS

ACKNOWLEDGEMENTS

Thanks to my family for their support. Thanks especially to Justin Ridley for enduring my enormous levels of anxiety to complete this book in time.

Thanks to Katie Stitely for encouraging me to write about what I love to talk about, and that is everything bees and honey related.

Thanks to The History Press for taking a chance on me.

Thanks to Ted Dennard at Savannah Bee Co. for believing in me.

Thanks to Gloria Hoffman at the USDA.

Thanks to Larry Haigh and Debbie Fisher for always giving me your support and encouragement.

Thanks to Caleb Quire and Chrys Rynearson for your amazing photographs.

INTRODUCTION

In 1859, North Carolina, South Carolina and Georgia produced a combined 3,535,961 pounds of honey, according to Bulletin 685 from the U.S. Department of Agriculture. This amount of honey was flowing at the dawn of a golden era in beekeeping. Beekeepers in the United States stood on the frontline of this fifty-year period when the world of keeping bees changed forever with inventions and patents of equipment from movable hives in hives to extractors and smokers. In our current time, beekeepers across the globe continue to adopt these designs from the late 1800s. The new ways of keeping bees helped benefit both the keeper and the bees and resulted in producing more honey faster and on a larger scale. Beekeepers have been around for thousands of years, and it was in this revolutionary time that a handful of men changed the honey industry forever.

Are you a beekeeper or an aspiring one? Do you like honey? If so, this book may be the dip on your chip, but it's not about how to keep bees. It's about the history of the people who produced honey and how they got started in this area of the country. Surprisingly, while compiling this book, I discovered more history and information than I could have imagined before sitting down with my pen and paper to write this. The publications, magazines, journals and even government support were plentiful, loud and clear with their encouragement of the profitability and benefits of becoming a beekeeper and the potential financial gain to producing honey. The honey and bee industry is a highly welcoming occupation but only if you truly put your heart into it.

Let me repeat: this is not a handbook for beekeeping. So whether you keep bees or not, this book will provide you with a taste of the sweet history of this small but important industry still growing in Georgia and the Carolinas today.

Our culture over the last few years has developed an attitude supportive of sustainable, domestic resourcefulness. This trend of doing things by oneself includes a growing interest in keeping bees, also referred to as urban beekeeping. From growing vegetables in the yard or community garden to brewing beer to composting, keeping bees for pollination and producing honey is peaking. CABA, the Charleston Area Beekeepers Association, started a few years ago with just a handful of folks and now has over one hundred members.

There is no doubt that for every beekeeper in the southeastern part of the United States, a unique story can be told of lessons learned, their triumphs and tragedies and the important people and mentors in their lives who shaped their heart and the art of their craft today. If I could have included each one of them in this book, I would have enjoyed that, but I don't think anyone really wants to read a twenty-thousand-page book about beekeepers and their honey. So I have broken down the three states of North Carolina, South Carolina and Georgia into separate timelines according to the amount of information that was available about honey and the bee industry in each state. Georgia is rich in its history of beekeeper information from around the end of the 1800s and the turn of the century. North Carolina is abundant in records located at the University of North Carolina on information about the education of beekeepers and the advancement of the industry in the early 1900s. And thirdly, South Carolina does not have as much historical information as the other states, so I have chosen to focus on the beekeepers and honey production of the more current times.

This book is full of facts and historical content about beekeepers and honey. I have also included in this book the story of a beekeeper and hero, J.J. Wilder of Georgia, once said to be the most successful beekeeper in the world. Wilder has much to share about the industry, and it is my hope that I will be able to share with you his message. E.F. Phillips, our second hero, was an apiculturist who worked for the Bureau of Entomology. He attended the first North Carolina State Beekeepers Association in 1917 and said, "No state has held ten meetings to equal this, and there is no state whose first meeting equaled this." Highlighted in South Carolina with their efforts to care for the bees in our world today are the everyday heroes in the bee industry, our current generation of beekeepers.

But the biggest hero in this story, above all the rest and singled out by thousands alike, is none other than the honey bee. We study her, we learn from her, we do our best to understand her needs, all because we need and love her. There is a lot of compassion for these little creatures, so much so that we have formed clubs and associations, magazines and journals and elected presidents and secretaries all among ourselves to one day be better at caring for her than we ever could have.

Bee veneration was inherited and not invented. The bee is a symbol of nature that man should follow, an earthly systematic community that thrives for the benefit of all, lives off the land and with love and harmony produces a never-expiring material that heals, nourishes and protects. What else on this planet even comes close to representing this world inside our world? And for the beekeeper, this world, in turn, can support his or her world by creating a commodity and a lifelong occupation that, unless overworked, really never tires. It's no wonder that through time our fascination with the honey bee has been recorded in cave drawings and artifacts. We are admirers of nature's teachings, and what a perfect teaching of society it is. Oh, the magic and mystery of the inside workings of the hive. Who are we to be in control of something already so in control of itself? The history of our early beekeepers, who have passed down from generation to generation what they have learned, deserves honor in their teachings and medals to its teachers.

Recently, I was looking through my collection of books stacked nicely on my bookshelf, and I noticed something that I had not paid much attention to before. There are twelve bee culture and honey books that sit on my bookcase. Of these twelve, I have subconsciously placed four of them by themselves on the top shelf. I had arranged my books like the back shelf of a bar. They sit there like fine whiskey, owning top-shelf rights. Of the five shelves, the bottom shelf has the books I rarely look through; the next shelf up has photo albums; the third and fourth shelves are my go-to books, including a rather large selection of beekeeping and home brewing books; and the top shelf has only a handful of very old, rare books about bee culture. Why, I ask myself, did I not file away my one-hundred-year-old beekeeping books with my modern books on bees? The reason, I thought, is because the writers of these books are our forefathers of beekeeping. Their messages are sacred. They may not be up to date with the most current revelations of beekeeping, but they are the roots of the written words of what I love so much. Therefore, in my subconscious mind, they deserve top shelf. If you have ever started a hobby and then found yourself creating a hobby of collecting books

about that hobby, then you're not alone. I'm one of those people too. It's fascinating to collect old artifacts and writings, poems and images of the ones before me, doing the same thing I take pleasure in. This revelation of honoring sacred old writings excited me with the desire to dig into the past and uncover more of what's sacred.

Everett Franklin Phillips, an important apiculturist and honey bee educator in the early 1920s, once said, "The most important part of beekeeping is above the neck." This prompts the question, of course, "Why the neck?" So I donned my cloak, pipe and detective hat and set out to explore the deeper meaning of what he meant by "above the neck" and what history had to say about this.

It was late August in South Carolina. I had not been out into the yard to check on the honey bees in over a month. The southern summer storms seemed to schedule themselves on the only days that I had available to suit up and light the smoker. But on this day, a break in the clouds came, and the sun was shining bright and hot outside like someone had left the light on in the oven. It was just past ten o'clock in the morning. My sights were set on getting into the hives to make sure the girls were still thriving and buzzing.

I had just started compiling this book, and like most writers, I had a block. Since I was writing about beekeepers and honey, my hope was to get into the hive and let the true heroes of the story rub their energy off on me.

In the summertime in the muggy, humid South, the thought of having to add one more layer of clothing is daunting, to say the least. It certainly forces one into the bravery of suit-less, gloveless beekeeping. So I donned my lightest armor, lit my smoker and marched through the tall, uncut grass toward the hive. On approach to the hive, it appeared quiet. Every terrifying beekeeper thought ran through my head as I got closer and closer. "Are they even in there? Did they swarm away? Is it overrun by hive beetles or the wax moth? Has a communal family of roaches, mice or lizards taken up residency? Ugh! I'm the worst beekeeper ever!" I suppose owning all the beekeeping books one can collect certainly doesn't boil down to making one a better beekeeper. I set the smoker down off to the front side of the entrance and saw a few bees land and take off at their front door. My heart beat fast, and the anticipation had built up quickly as I prepared for the worst. Holding my breath, I opened the first lid and pried open the inner cover with my hive tool. Peeling back the wooden cover, I took a deep breath and felt a huge sigh of relief to see that I'm not the horrible keeper that I only moments earlier had convinced myself of being. I was greeted by the sight of eight full frames of black and yellow

six-legged fuzzy-buzzy bees crawling around doing their thing, while some looked up at me blinded by the sun coming up over my shoulder. A soft hum rising from the colony into the warm rays of the morning sun filled the air. I pulled out a frame and inspected the work of my whistling little dwarfs. (If they did indeed all have names, I would feel sorry for the bee nicknamed Sneezy. Working in the flowers all day would be hell!) The uncapped honey in the combs shined and glistened in the light, and the girls flew all around keeping their eyes on me and their prize. I had been in the hive a dozen times before throughout the early summer, but this particular day, the bees seemed different, happy. The sound from the hive was of contentment.

Jack Mingo, the author of *Bees Make the Best Pets*, says that the adult bee when inside the hive makes the sound of 190 vibrations per second, or what is referred to as a note halfway between the F# and G below middle C on the piano. He continues, writing that what's even more interesting is that when they fly, the tone bees make becomes a B at 248 vibrations per second. Mingo also asks the question, humorously, that when bees fly in B natural, do they sting in B sharp and hit a windshield in B flat?

Throughout my process of gathering historical information for this book, a common theme arose from articles and publications about what sets apart the good beekeepers from the bad or, rather, unsuccessful. Unlike owning a dog or lawnmower, beekeepers don't just "keep" bees. They conduct them like an orchestra in the orchard, paying attention to timing and moving pieces and parts around like syllables in a quartet. They have to constantly adjust, maneuver and rely on listening to their own instincts until the end of every honey flow season, before applauding their masterpiece of production. I have never looked upon any musician and thought, "Oh, that looks easy to play," and the truth is, neither is beekeeping. But like the beautiful sound of music that fills the soul, as a beekeeper, I can't stop listening.

Chapter 1

THE ANCIENT KEEPERS

Georgia and the Carolinas are surprisingly rich in the history of keeping bees and producing honey. Interestingly, this area was an influential part in the growth of what was the golden age of beekeeping. This era of development in the later part of the 1800s shaped how bees are now kept throughout the world today. But the story doesn't begin here in the southeastern part of the United States. The art of keeping bees and eating honey dates back thousands of years. There is a large amount of information written across time that references interest and symbolism of the honey bee. As great as the amount of information is out there about the relationship people had with bees and honey, this book is intended to focus on the buzzing history relative to the southeastern area of the United States. So we will skip and jump through a distant history until we reach the colonial era of America. Let's go back a few thousand years to the other side of the world and look at the progression of beekeeping throughout the centuries.

Humans have been hunting and collecting for thousands of years one of Mother Nature's sweetest nectars on earth: honey. Man discovered very early on that honey was not only a sweet, sticky find but also a great energy food source and was beneficial to one's health. In prehistoric times, there weren't too many sources of sweetness easily available, as you can imagine. A sugary source was only found in the juices of fruits and berries and, of course, only when those were in season. It's doubtful the caveman was preserving and canning at this time, so if it wasn't hanging off the tree or growing on a vine, it probably wasn't around. Interestingly, honey is the

only food eaten by man (and the occasional curious bear) that is produced by an insect. This golden food, made of nectar from blooming flowers, was not only delectable but is also known for its antiseptic properties and was used as medicine and as a preservative. Evidence of honey and beeswax being used during embalming and mummification in ancient Egypt has been examined. Bodies were preserved in wax-dipped linen bandages that prepared them for the afterlife. Wax from empty honeycomb was also valued for numerous uses, from sculptures of art or deities to use as a sealant or a medicinal ingredient. Encaustic (which means "burned in"), melted beeswax with added pigment was applied hot in a liquid form to walls and surfaces. This gave them a lustrous and rich effect. It was also used to create art.

Pre-agricultural humans went to unimaginable lengths searching for honey. In 1919, a series of rock paintings was discovered in a cave in Valencia, on the coast of Spain, that may have been drawn ten to thirteen thousand years ago. One scene portrays a hunter climbing a ladder or hanging vines from a cliff side while holding a basket of some kind and with what look like bees flying all around. This is truly an early image of man and bees in the wild.

So if you can, imagine a caveman volunteering—or choosing the shortest stick in the group—to make that climb (without proper protective clothing), cutting down the hive (with an unhappy protest from the bees) and safely finding his way back down the ladder without a sting or a fall. To prove manhood or bravery, a man may have easily charged toward the opportunity to be the hero: fighting off angry bees, collecting honey and getting the honor of bragging to the women back at the cave about how he single-handedly scaled the mountain and fearlessly collected the golden liquid. Of course, he probably added to his story that he did it all with one hand.

Bee lining, an ancient art of hunting for beehives, has been in practice for thousands of years. The hunter would use a baited box to catch bees and then release one or two bees at a time and note the direction of their flight. Bees fly in a straight line when returning to their hive, so the hunters would follow them back to their pot of golden honey hiding in a tree. Beekeepers—honey robbers, if you will—have certainly come a long way since then. One was lucky to discover a busy hive but unlucky if he suffered the aftermath of prospective stings. Here's an interesting reminder: epinephrine shots or Epi-pens weren't available then like they are today.

Honey bees or, as they are called in Latin (for those who may still speak it), *Apis mellifera* were perhaps much different during primitive times. They could have been a gentler species and less aggressive toward the looting of their lot than most bees today. Valencia, Spain, where the primitive paintings were

found, sits just across the sea from Italy. Rumor has it that the Italian bees were known to be docile and less aggressive than most other bees, like the Russian or African bees. Therefore, it may not have been such a single-sided sword fight as one would image when seeing a hungry, ego-driven caveman scale a hillside to take honey from thousands of hardworking Apis.

How exciting to the primitive man if, while out hunting for food, he discovered an active, well-stocked beehive. The feeling must have been equivalent to a modern-day experience of finding a winning lottery ticket or, to Charlie, a golden ticket to the chocolate factory, a place with nothing but heavenly sweet goodness inside. The treasure inside a hive was like finding gold back in those days. What could have been more exciting to gather in nature besides gold itself? Ironically, history reveals that honey was indeed used as a substitute for gold to pay taxes by the Romans. Too bad that doesn't work on April 15 nowadays.

The oldest remains of actual honey were found in Georgia. Sorry, but it's not the Georgia y'all would like to think I'm referring to. It was the country Georgia, where archaeologists discovered honey on the inner surface of a clay vessel in an ancient tomb that dates back about five thousand years.

In Egypt, around 2400 BC, drawings of beekeepers and honey preparation were drawn on the walls of ancient temples. It is not known exactly when people began to keep bees, but they must have had knowledge about bee life, observed the communal workings of a colony and understood that the one large bee among the crowd was the only one in control. The Egyptians understood this role and depicted their king with this same symbol of majesty. The bee was used as an insignia in ancient Egypt; this figure denoted the king of Lower Egypt, also referred to as *Bi'ty*, which means "he who belongs to the bee." This bee hieroglyph is found on inscriptions from the first dynasty down to the Roman period, roughly one thousand years. The Egyptian book of Amen Ra—yes, the same book mentioned in the movie *The Mummy* from 1999 with the then-handsome Brendan Fraser and the very lovely Rachel Weisz—refers to the sun god Ra and states, "When Ra weeps again, the water which flows from his eyes upon the ground turns into working bees. They work the flowers and trees of every kind and honey and wax comes into being." This signifies that bees were not just revered as agricultural contributors and a special source of food, but their existence and manner was woven into everyday life and religion as well. The honey bee colony, a perfect society, it seems, flourishes with harmony and liquid gold. Is this not what most people would refer to as heaven? Streets paved with gold and winged angels singing in the background? The book of Amen

Ra also refers to the sound of bees humming as what angels who sing to the sun god would sound like.

A bit more recent than the images found in Egypt is a discovery made in the fall of 2007 hundreds of miles away from Egypt, in Tel Rehov, Israel. Thirty intact beehives were reportedly found dating back to the mid-tenth century BC. The beehives were evidence of an advanced beekeeping industry three thousand years ago.

In 1900, a German expedition excavating Abusir, Egypt, found an area that depicts an extremely advanced beekeeping industry that was highly organized, with hives made from clay that resemble tubes and taper slightly to the end, with each of the tubes fastened to an adjoining one. This beekeeping technique is still used in the Nile Valley.

Around 1259, Thomas Cantimpre, a Dominican monk, wrote about the comparison of the life of bees with the role and duties of a Christian, with special emphasis on the clergy and the monks. He states that there is but one king bee in the hive and this is to prove that there can and should be only one king (one pope) and that this king does not use his sting, so bishops must be mild.

Honey bees expanded to North America with human-assisted migration during the seventeenth century. Many Europeans fleeing wars, poverty, land laws or religious persecution brought extensive beekeeping skills to the United States during the next two centuries. Meanwhile, English colonists took bees to New Zealand, Australia and Tasmania, completing human-assisted migration of *Apis mellifera* around the globe.

Chapter 2

A BUZZ ON THE AMERICAN REVOLUTION

Honeybees were not always native to North America. Who knows which brave soul decided to travel across the seas with hundreds if not thousands of bees aboard his ship first? It has been recorded that colonies of bees were shipped from England to the colony of Virginia in 1622. My guess is that the *Mayflower* would have been their luxury sail of choice. Surprisingly, it wasn't until one hundred years later, in 1743, that honey bees became present in Georgia. It seems to have taken them a few years to figure out they should fly south for the winter. By 1830, they had traveled as far west as Alaska.

Early beekeepers kept bees in wooden boxes, pottery vessels or straw skeps (the popular image that resembles an upside-down straw basket). Around the middle of the 1800s, beekeepers were keeping bees in hollow logs called bee gums. These gums were tree trunks hollowed out by decay. They increased their number of colonies each spring by capturing swarms and killed them in the fall by burning sulfur at the entrance of the hive so that the honey and beeswax could be removed; some of these bee gums could yield up to four hundred pounds of honey.

In 1849, *The American Bee Keepers Manual*, by T.B. Miner, was published as a practical treatise on the history and domestic economy of the honey bee, embracing a full illustration of the subject, with the most approved methods of managing this insect through every branch of its culture, the result of many years' experience. The author wrote this book to bring attention to the neglect of management of the honey bee in the United States.

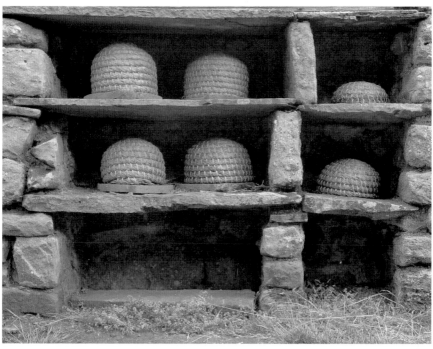

If you Google the definition of "colonial" and look under the Wikipedia page, it says that a colony is a territory under the immediate political control of a state, distinct from the home territory of the sovereign. It also states that the word "colony" comes from the Latin word *colōnia*. This, in turn, derives from the word *colōnus*, which means colonist but also implies a farmer.

In their book, *For Every House a Garden: A Guide for Reproducing Period Gardens*, Rudy and Joe Favretti, state:

> Colonists were quick to adopt beekeeping: "Bees, on the other hand, were often a feature of early gardens. Their value as pollinators and honey producers was much appreciated. Hence, bees were incorporated into the garden and orchard. An elaborate skep was not always present because a hollowed log would serve just as well. At the time of the American Revolution 1765 to 1783, about ninety-four percent of all people in the US were engaged in farming. Most farmers had their farmstead, which consisted of a few acres, and then somewhere else they had their meadows, fields, and woodlots. Large scale crops, such as hay, corn, and, perhaps, even pumpkins and turnips, were grown away from the homelot, but the smaller scale crops, such as, peas, cabbages, radishes, carrots, garlic, onions, leeks, melons, herbs, and beans were planted in gardens near the house. These homelot gardens were tended by the women of the household.

George Washington (1732–1799), America's first president, may not have been a beekeeper, but he did subscribe to a magazine called the *Bee*, a weekly journal related to agriculture and economics that was published from 1790 to 1794. The author and editor of this magazine, James Anderson (1738–1808), wrote to Washington from Edinburgh, Scotland, in September 1791, enclosing six volumes of the *Bee*. George Washington replied to Anderson the following June: "As I spent a great part of my life (and that not the least pleasing) in rural affairs, I am always obliged by receiving such communications or novelties in that way, as may tend to promote the system of husbandry in this country."

An excerpt from the *Bee* describes the horrific and inhumane way of collecting honey: "We now come to the most inhuman practice of taking

Opposite, top: Underneath a skep, a honeycomb is exposed. *Courtesy of Gyulavári Csaba.*

Opposite, bottom: Skep beehives made from straw. *Courtesy of Herman Hooyschuur.*

bees, which involves destroying the whole swarm. Were we to kill the hen for her egg, the cow for her milk, and the sheep for the fleece? And yet this is practiced every year in regard to bees. A hole is dug near the hive a rag dipped in brimstone is placed in that hole and the rag set on fire, the smoke cannot escape and in a quarter of an hour all the bees are seemingly dead." Since Washington enjoyed this paper, he may have even read this very same article in the volumes that were sent to him.

John Adams (1735–1826), the second president of the United States, kept a diary. In it, he writes, from an excerpt dated July 25, 1786:

We returned by another road through the race grounds, to the Hide and after Dinner, made a Visit to the Gardiners House to see his Bees. He is Bee mad, Mr. B. Hollis says. He has a number of Glass Hives, and has a curious Invention to shut out the Drones. He has nailed thin and narrow Laths at the Mouth of the Hive, and has left Spaces between them barely wide enough for the small Bees to creep through. Here and there he has made a Notch in the lath large enough for a Drone to pass, but this Notch he has covered with a thin light clapper which turns easily upwards upon a Pivot. The Drone easily lifts up the Clapper and comes out, but as soon as he is out, the Clapper falls and excludes the Drone, who has neither Skill nor Strength to raise it on the outside. Thus shut out from the Hive the Gardiner destroys them because he says they do nothing but eat Honey. The Gardiner who is a Son of Liberty, and was always a Friend to America, was delighted with this visit.

Our third American president, Thomas Jefferson (1743–1826), wrote notes about the natural history of the land and its people in the state of Virginia; he analyzed the population, manufactures, military force, rivers, boundaries, climate and, surprisingly, the honey bee.

The honeybee is not a native of our country. Marcgrave indeed, mentions a species of honeybee in Brazil. But this has no sting, and is therefore different from the one we have, which resembles perfectly that of Europe. The Indians concur with us in the tradition that it was brought from Europe, but when and by whom we know not. The bees have generally extended themselves into the country a little in advance of the settlers. The Indians, therefore, called them the white man's fly, and consider their approach as indicating the approach of the settlement of the whites. A question here occurs, how far northwardly these insects have been found.

First written for the *Sunday School Advocate* and reprinted by *American Bee Journal* in September 1917 is the story of Miss Charity Crabtree:

> *The brave patriots of the American Revolution were having a particularly hard time of it in the summer of 1780. General Washington and his ragged, half-starved soldiers were in camp just outside of Philadelphia, where it was certain that the enemy was getting ready to make an important move. Man after man had risked his life trying to get their secret, but so far no one had been able to give Washington the important news without which he dared not risk his small force in battle. But the great Washington, himself, scarcely took the independence of the colonists more seriously to heart than did little Mistress Charity Crabtree. Despite her prim Quaker ways, no eyes could spark with greater fire at the mention of freedom than those that smiled so demurely above her white neckerchief and plain gray dress. Charity was a soldier daughter, and though his patriotism made her and her brother John orphans, when the boy also left to fight for his flag, Charity did not shed a tear, but handed him his sword and waved him Godspeed. Though she was all alone now and only twelve years old, the little maid kept a stout heart. "If I hold myself ready to serve my country, I know the time will come," she said, as she walked back from the gate through the fragrant lane, Honeycombed with beehives. "Meanwhile, I must keep my bees in good order." Charity's father had been a bee farmer, and he kept all these hives at the entrance of his lane, so the bees could search the highway for wild flower sweets. One of his last acts was to send a beautiful comb of their honey to General Washington, whereupon the General had smacked his lips and said: "Those bees must be real patriots. They give the best that is in them to their country." Charity stopped now to notice how well the bees were swarming. They seemed particularly active this morning, but she was not afraid of these little creatures who do not sting unless they are frightened or attacked. "I shall have a great many pots of honey to sell this fall," she thought. "It is good Providence who inspires the bees to help me keep our little white house all by myself, until brother John returns." Then suddenly the little Quaker maid turned pale. She stopped for a second with her hand to her ear, and then she ran quickly to the highway. These were terrible times, when, at any moment, bullets might whizz about like hailstones, and every good colonist lived tensely, in fear the little American army would be captured and their brave fight for independence lost forever. It was a man in citizen's dress who galloped down the road. His hat was blown off and he pressed his left hand to his side. When he saw Charity*

he just was able to rein in his horse and, falling from his saddle, draw her close so she might catch the feeble words he muttered between groans. "You are Patriot Crabtree's daughter?" he murmured, and the girl nodded, as she raised his head on her arm. "I am shot, I am wounded," he gasped. "Leave me here, but fly on my horse yonder to General Washington's camp. Give him this message: 'Durwent says Cornwallis will attack Monday with large army.' Do not fail him!" cried the man. "Be off at once! The enemy is pursuing close." Poor Charity had just time to repeat the message and assist the fainting man to a grassy place under the elm tree's shade, when the air thundered with a thudding of hoof beats, and before the terrified girl could gain her horse, a dozen soldiers leaped over the garden wall at the back of the house. "For my country!" the plucky maid cried, and leaped to the saddle. But even then she realized that if once the British saw her they could easily remount their own horses, evidently left on the other side of the wall, and so capture her and prevent her from reaching Washington. As it was they discovered the unconscious soldier, whom they quickly surrounded by a guard, then spied the fleeing girl and immediately gave chase. "Ho, there!" they cried. "Stop, girl, or by heaven we'll make you!" They crowded after her into the mouth of the lane, while Charity cast about hopelessly for some way of escape. Suddenly, with the entrance of the soldiers, the bees began to buzz with a cannon's roar, as if to say, "Here we are, Charity! Didn't Washington say we were patriots, too? Just give us a chance to defend our country!" Like lightning, now, Charity bent from her saddle, and seizing a stout stick, she wheeled around to the outer side of the hedge that protected the hives like a low wall. Then, with a smart blow, she beat each hive until the bees clouded the air. Realizing from experience that bees always follow the thing that hits them rather than the person who directs it, she threw the stick full force at her pursuers. As Charity galloped off at high speed she heard the shouts of fury from the soldiers, who fought madly against the bees. And, of course, the harder they fought, the harder they were stung. If they had been armed with swords the brave bees could not have kept the enemy more magnificently at bay. While Charity was riding furiously miles away, down the pike, past the bridge, over the hill, right into Washington's camp, her would-be pursuers lay limply in the dust—their noses swollen like powder horns. When the little maid finally gained admission to Washington's tent, for to none other would she trust her secret, the great general stared at her gray dress torn to ribbons, her kerchief draggled with mud and her gold hair loosened by the wind. But Charity had no time for ceremony. "I have a message for thee,

sir," she said, standing erect as a soldier beside the general's table. "I have ridden these many miles while a dozen of the enemy have been kept at bay so I might bear it." When she gave Washington the message he sprang from his seat and laid his fatherly hand upon her shoulder. "The little Quaker maid has saved us," he said, and his voice rang while he looked deep into her gray eyes, lighted with honest loyalty. "I brought the message only as I was directed, sir," she said. "It was my bees that saved their country." You can imagine Washington's surprise and that of his officers who crowded in with warm praise for the girl, when Charity told them of the story of the patriotic bees. Washington laughed. "It is well done, Little Miss Crabtree," he cried, warmly. "Neither you nor your bees shall be forgotten when our country is at peace again. It was the cackling geese that saved Rome, but the bees have saved America."

TO CIVIL THE WAR

B y the mid-1700s, honey remained the general article of local trade in North Carolina, while beeswax, used most frequently for candles and in some cosmetics, became a minor export in the state. The colonial government recognized the economic value of beeswax, authorizing its use for taxes under the 1745 Quit Rent and 1768 Tax Acts, at the rate of one shilling per pound.

Offering high rewards and requiring little effort, beekeeping was well established across the state through the 1800s. Plantation owners and small farmers both kept hives. The state of North Carolina's honey production reached its peak of 2.5 million pounds per year around the turn of the century. The early decades of the twentieth century saw a growing awareness of the importance of beekeeping in that state.

On April 12, 1861, Confederate forces fired on Fort Sumter off the Charleston Harbor in South Carolina. In the diary of a young girl named Hattie Brunson of South Carolina, during this time of the Civil War, she wrote about soldiers ransacking her family's house, but to their dismay, the family got a good laugh when seeing one of the soldiers try to steal the wrong commodity from their home: the honey. Mr. Brunson kept bees, so one of the soldiers decided he would like to have some honey. It was obvious that he knew nothing of the habits of bees, for he marched boldly up to one of the hives and smashed it open. When he raised his head, it was literally black with bees. With a wild yell, he tore off frantically down the road to the accompaniment of the delighted laughter of the

American Civil, by Edwin Forbes, 1876. *Courtesy of the Library of Congress. LC-DIG-ppmsca-20764.*

Brunsons. According to an interview given years later, Hattie states that as terrible as the situation was, the Brunson family got at least one good laugh at the expense of the Yankees.

For bee-culture is woman's work. It brings her more than money: the open
air and exercise that the care of bees calls for will in nearly every case,
cure most of her bodily and mental ills.
—*Hunter MacCulloch, 1884*

After the Civil War, many women found themselves left as widows or had wounded husbands return home unable to work. Born in Georgia, Sarah Elizabeth Sherman moved to Texas to become one of the most successful commercial beekeepers in that state. A question much discussed in books and journals on bees is that of beekeeping for women. According to E.F. Phillips in his book, *Beekeeping: A Discussion of the Life of the Honeybee*, written in 1918, his thoughts about women and beekeeping were positive in that many women can and do handle bees with much success, especially in parts of the business that require detailed attention and a soft hand, such as queen rearing. He notes that women often surpass men in proficiency. Phillips notes that it should be made clear that the obstacles to the commercial success of female beekeepers are physical ones only, and as amateur beekeepers, they are at home. The question that usually presents itself, however, is whether beekeeping is suitable for women as a means of earning a livelihood, and repeatedly Phillips was asked for advice on this subject. Professional beekeeping on a large scale to sufficiently supply an adequate income requires long hours of work in the hot sun, heavy lifting and unremitting physical endurance. On a small scale, these obstacles may be overcome, but in a commercial apiary, the work must be done promptly, for delay means loss. "While some women have found pleasure and profit in the commercial beekeeping, it emphatically cannot be recommended for the majority of women, and this should be made clear to avoid disappointment for those who may be attracted to it," wrote Phillips. Of course, this applies only to those women who have no man in the company to do the heavy work.

Chapter 4

KEEPING BEES IN THE
TIME OF WAR

HONEY, WHERE'S THE SUGAR?

Does a spoonful of sugar really help the medicine go down? If you were living during World War I, being a beekeeper would have been a "sweet" market to tap into as cane sugar was being rationed for the war. The government asked the American people to limit the use of sugar to only two pounds per person per month, a decrease from the sixty pounds individually consumed on average each year. The United States made an effort to conserve food and other materials that were supplied to troops abroad. People were encouraged to follow rationing days by having "Meatless Mondays" or "Wheatless Wednesdays." This ration made honey more and more desirable for the sweet tooth–inclined. To have had a busy hive or two buzzing in the backyard would have been the lagniappe for that southern pitcher of tea. And for those in the South, war or no war, please don't take away the sweet tea!

Rationing started again in the Second World War, and the first food to be rationed was, again, sugar. The war had cut off U.S. imports from the Philippines due to our unfriendly terms with Japan, and shipments from Hawaii were deferred to only military use. America's supply of sugar was quickly reduced by two-thirds. If you wanted to buy sugar, you had to use a stamp from the rationing booklet that the Office of Price Administration issued. A total of 123 million copies of the book were sent out. It wasn't until 1947 that sugar could be legally bought without the stamps.

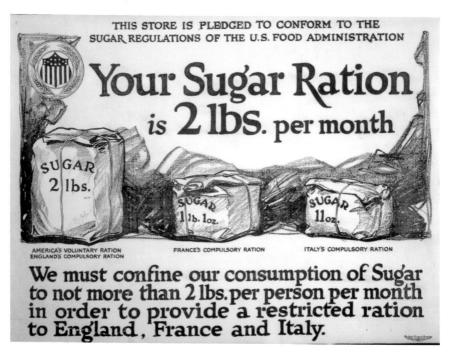

THIS STORE IS PLEDGED TO CONFORM TO THE
SUGAR REGULATIONS OF THE U.S. FOOD ADMINISTRATION

Your Sugar Ration
is 2 lbs. per month

SUGAR
2 lbs.

SUGAR
1 lb. 1 oz.

SUGAR
11 oz.

AMERICA'S VOLUNTARY RATION
ENGLAND'S COMPULSORY RATION

FRANCE'S COMPULSORY RATION

ITALY'S COMPULSORY RATION

We must confine our consumption of Sugar to not more than 2 lbs. per person per month in order to provide a restricted ration to England, France and Italy.

A sugar ration stamp. *Courtesy of the Library of Congress. LC-USZC4-9564.*

E.F. Phillips earned a PhD in biology and was in charge of bee culture investigations, Bureau of Entomology, at the USDA in 1918. While overseeing commercial beekeeping during World War I, honey production increased 400 percent, in part due to his efforts to bring the beekeeping industry up to modern scientific standards. Thirteen years prior in 1905, Phillips wrote an article for *Scientific Monthly*, in which he claimed that the United States could produce 200 to 250 million pounds of honey a year. This amount was sufficient to provide a little over two pounds for each person annually. He believed that the amount of nectar secreted by the multitude of flowers across the country was beyond comprehensible and would far exceed the amount of sugars consumed by the American person, who obtains it mostly from cane and sugar beets. He stated that of all the insects, only the honey bee is capable of collecting this sugar supply, but it is wasted sugar that misses the opportunity for profitability. The nectar from flowers is so soon lost after it is produced. He felt regretful that there were just not enough commercial beekeepers in America to harvest two or three times the amount of honey produced in 1917.

Fast-forward one hundred years to 2013, and reports state that honey producers in America with five or more colonies harvested only 149 million pounds, according to a report by the National Agricultural Statistics Service, U.S. Department of Agriculture, in March 2014. This number does not include the amount of honey produced by smaller beekeepers with fewer than five colonies. But even if their amount matched the commercial producers by today's total, Phillips would be undoubtedly disappointed, to say the least. If the calculator reads it right, that is 100 million pounds less than the potential Phillips believed America could live up to.

According to the U.S. Department of Agriculture Honey Production Census in 1909, Georgia produced 884,662 pounds of honey. North Carolina brought in 1,809,127 pounds, and South Carolina weighed in at 653,119 pounds.

War Brings New Beekeepers

The First World War brought a new kind of beekeeper: the disabled veteran. In 1919, the Federal Board of Vocational Education issued an opportunity monograph to the disabled soldiers, sailors and marines to aid them in choosing vocations. It noted to the disabled soldiers that the surgeon general; war department and all its employees; bureau of medicine and surgery; navy department and all its employees; and Federal Board of Vocational Education were mutually interested in their warfare experience. This monograph explained the business of beekeeping and noted that if the soldiers decided to undertake it as a profession, the board would offer an intensive course in the culture to assist them in becoming efficient and financially successful beekeepers. Uncle Sam offered assistance for artificial limbs, interchangeable devices and vocational training for the vet turned beekeeper in every possible way to help him succeed. The monograph noted:

> *Beekeeping, like many other lines of agriculture, presents an exceptionally attractive and profitable vocation to the disabled men of the war. The handling of bees is interesting and encourages the most valuable exercise, but the muscular effort is small. It probably requires less constant devotion, except during the main honey-flow, than any other country pursuit. Therefore it is especially attractive to the convalescing or those who have recovered from wounds, even if they have lost one or more limbs. Though handicapped in*

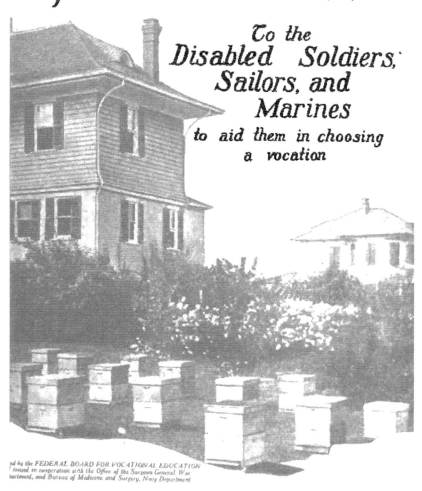

Opportunity Monograph
Vocational Rehabilitation Series No. 37

Bee Keeping

April 1919

To the Disabled Soldiers, Sailors, and Marines

to aid them in choosing a vocation

ed by the FEDERAL BOARD FOR VOCATIONAL EDUCATION
Issued in cooperation with the Office of the Surgeon General, War
bartment, and Bureau of Medicine and Surgery, Navy Department

"Opportunity Monograph" to disabled soldiers in 1919. *Courtesy of the United States Federal Board for Vocational Education.*

various ways you may confidently hope to become as near 100 per cent in bee culture as in any other work. A beekeeper should, however, have one good hand and arm.

This article assured wounded soldiers that if they wanted to approach this vocation as a career, it was possible for them to do so. The pictures presented in this article show a post–Civil War man by the name of Mr. John Donnegan and Mr. Harvey Nicholls as examples of disabled veteran beekeepers. *American Bee Journal* first wrote an article about Mr. Nicholls in May 1919. Eric Millen, who wrote the article for the journal, titled it "You Can If You Will." Nicholls had lost both his legs in a boiler explosion in 1911 at the age of twenty-one and was now a beekeeper. Prior to the accident, Nicholls did not have much ambition until he realized that life was ahead and that he had to make it good.

So in 1915, he purchased his first hive. He did not make any honey the first year but secured the bees through winter and in 1916 bought a book on keeping bees, studied it well, visited local successful commercial beekeepers and had eighty pounds of honey by the season's end. The following year, he grew to having three more hives and worked for a honey supply company assembling hives while still working with his bees at odd times. By the end of 1917, he was up to twelve colonies and four hundred pounds of honey. Nicholls did hire an assistant to help with some work in his apiary, like lifting supers to transport in his outfitted secondhand Ford that Nicholls drove using an artificial limb.

As World War I went on, there was a decrease in sugar being sent over to the soldiers, and thus the next best sweet thing that provided energy was honey. This, in turn, raised the price of honey. Never had

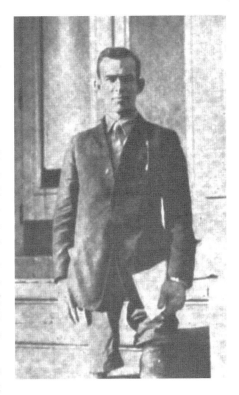

Harvey Nicholls lost both his legs in a boiler explosion and became a beekeeper. From the "Opportunity Monograph" to disabled soldiers in 1919. *Courtesy of the United States Federal Board for Vocational Education.*

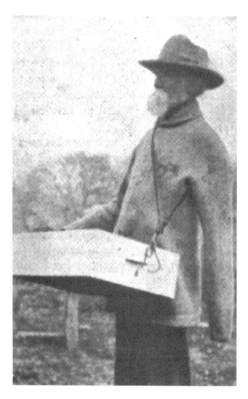

Mr. Donnegan was an example of a disabled veteran beekeeper. "Opportunity Monograph" to disabled soldiers in 1919. *Courtesy of the United States Federal Board for Vocational Education.*

there been a better time to learn bee culture than when the country was in need of more beekeepers. It was a promising way to earn a good living. Becoming a beekeeper had its other advantages for the postwar, traumatized, wounded soldier: it was a great opportunity for peaceful healing while working in solitude and a good therapy for PTSD (post-traumatic stress disorder) and also for the newly coined term "shell shock."

There were a handful of great beekeeping men who were chosen to teach the soldiers bee culture, among them George Demuth, Frank Pellet, Jay Smith, M.I. Mendelson, E.R. Root and E.F. Phillips. Phillips was reluctant to teach beekeeping to just anyone, as the failure rate to successfully understand how to keep bees was high, but he was excited to teach soldiers returning from the war, and he was passionate about America needing more commercial beekeepers to tap into the uncollected nectar all across our country. He stated, "The most important part of beekeeping is above the neck," and the issued monograph confirms that, telling its readers, "Heads, you win! From the neck down you may be worth $1.50 per day; from your neck up you may be worth any price, provided you will get prepared to do well with the occupation which you and the representatives of the federal board find to be most suitable for you with your handicap."

Phillips felt strongly that a man should produce enough honey as a beekeeper to rely on it solely for his livelihood. He wanted a person to see the bigger opportunity, to grow as a successful commercial beekeeper, and didn't want to waste time with those who did not have a strong interest and desire to achieve this.

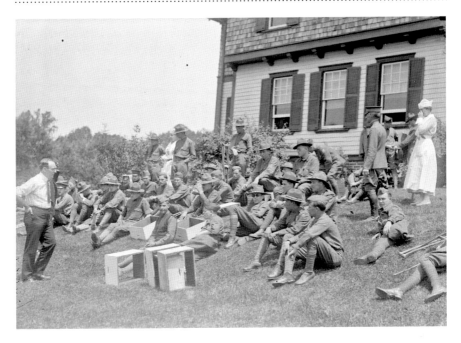

Everett Franklin Phillips teaching beekeeping to disabled vets. *Courtesy of the Library of Congress. LC-DIG-hec-12166.*

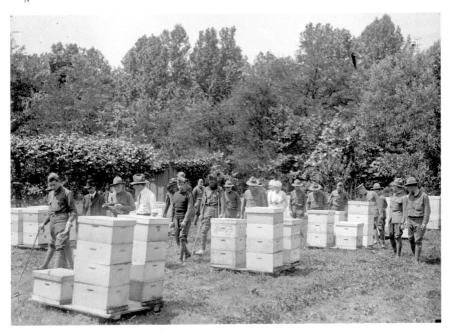

Disabled vets strolling the hives at Fort McPherson, Georgia, 1918 or 1919. *Courtesy of the Library of Congress. LC-DIG-hec-12169.*

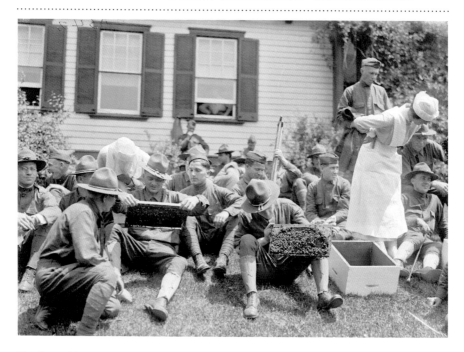

Up close with the bees, soldiers learn bee culture. *Courtesy of the Library of Congress. LC-DIG-hec-12171.*

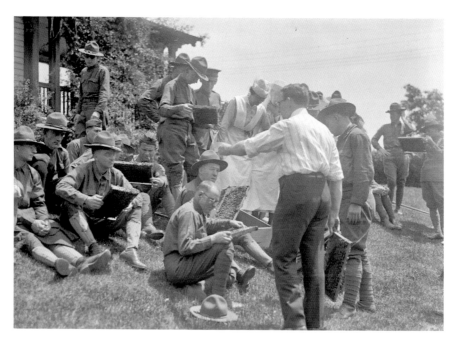

World War I disabled vets learning bee culture. *Courtesy of the Library of Congress. LC-DIG-hec-12174.*

On April 23, 1917, an emergency beekeeping conference was held in Washington, called by E.F. Phillips. He encouraged beekeepers across the country to stimulate production of honey during this time of war as a measure of necessity in food product shortage. Phillips stated:

Realizing that the present crisis into which the nation has been forced is a supreme test of usefulness to our industry and believing implicitly in the devotion of beekeepers as a class to their country, the undersigned persons have in conference taken it upon themselves to speak to the beekeepers of the country in making specific recommendations to the end that our industry beekeeping, may fulfill its highest obligation. We call upon you to do your part and suggest the following things specifically. We urge honey producers to increase production to the greatest possible extent, giving preference to extracted honey because in that way total honey supply may be more greatly increased. The inspectors of apiaries to emphasize educational work, even to take precedence over inspection of individual colonies, in order that they may carry the message of greater production to more beekeepers. Beekeepers to organize county or local associations for the rapid dissemination of information, these local associations should be affiliated with state associations which in turn should join a nationwide organization. Never before was there such need of an organization of beekeepers for educational purposes. The bee-journals and agricultural press to cooperate this movement and especially we ask that they present regularly to their readers reliable market quotations and crop estimates. We urge the teachers of beekeeping and extension workers to increase their activities and to cooperate with the Department of Agriculture in instructing beekeepers how to increase honey production and in rational distribution of the crop. To the end that there may be as little as possible in the movement of bees, honey, beeswax, beekeeping supplies and honey containers, we have selected a committee to cooperate with the government agencies in giving preference to such commodities in freight shipments. We order that the manufacturing supplies to continue their present policy of operating their physical capacity in order to send off the supplies for the 1917 crop to be available. We urge the agents and dealers in supplies to immediately ship the beekeepers goods on the day the order is received. We especially call attention of producers to the necessity of ordering the necessary supplies early and to order standard goods in order to save time at the manufacturing plants. We ask beekeepers to supply themselves with liberal quantity of containers immediately in order that the present seeming shortage in tin and glassware may not prevent

the sale of their crops. We recommend to every beekeeper the desirability of selling as much of his honey as possible on home markets. If this is done it will bring greater profit to the beekeeper himself commensurate with the cost of production and retail handling, will help to relieve freight congestion and will offer opportunity for the beekeeper who cannot sell at home to get a living price for his product. There are few places in the United States where a home market cannot be developed and already ninety percent of the honey crop is so sold. We ask those who sell honey at wholesale not to sell their honey until they have full information concerning the needs of wholesale markets. Especially we commend those inspectors; teachers and associations officers who have so cordially and loyally respond[ed] to the demands of the present crisis and ask them to continue this effort. Finally we call upon all beekeepers and all those whose chief interest in the up building of the beekeeping industry to redouble their efforts to increase the importance of beekeeping as an agriculture industry which conserves a national resource and which produces a non-perishable, wholesome food and we pledge ourselves to this work.

During the Second World War, the Honey Industry Council persuaded the U.S. federal government to exempt beekeepers the use of sugar and wood from rationing so that they could feed their bees in the winter and make new hives to expand their colonies. This was so that beekeepers could continue supplying the government with beeswax and honey. Beekeeping was so important during the war that the beekeeping magazines were not suspended like they had been during the Civil War.

There was an increase in motor vehicle usage after World War II. More highways were being established, and commercial beekeepers throughout the United States were able to expand the size of their businesses with more efficient methods of managing colonies in multiple apiaries and honey transporting. In 1957, an estimated 1,440,000 colonies were operated by professional beekeepers in the United States. By that time, hobbyists had a few colonies, the part-time beekeepers kept from 25 to 300 colonies and commercial beekeepers had up to several thousand colonies. One beekeeper in particular out of Georgia owned as many as 30,000 colonies.

Post World War II also saw the decline of honey prices as sugar became more available. Heavy outbreaks of infectious diseases in bees like European foulbrood in the 1950s nearly made beekeepers go bankrupt. A decade before in the 1940s, two professors at the University of Missouri had discovered that sodium sulfathiazole controlled the American foulbrood and could be

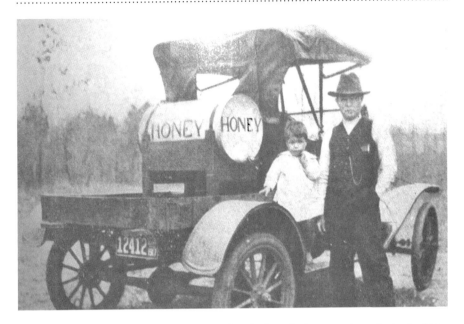

A Georgia beekeeper services his customers directly from the honey tank on the back of his car. *Photo taken from* Beekeeping in the South: A Handbook on Seasons, Methods and Honey Flora of the Fifteen Southern States, *written by Kennith Hawkins. Published by* American Bee Journal, *1920.*

used instead of having to transfer bees and burn diseased hives. Most states by then had made a law to burn and destroy infected colonies so as not to allow the disease to spread.

VETERANS GO TO COLLEGE

The Apiculture Program at North Carolina State University has a long and interesting history. A Rehabilitation Department for the training of disabled ex-servicemen of the world war was formed at the college in 1921. Of the various courses offered, one of them was beekeeping. Some took the course because it presented them with a diversion, while others entered their studies with diligence that resulted in producing experienced beekeepers in just two years, under the direction of Frank Capps.

The college apiary was divided into three divisions consisting of a central plant and two apiaries, which housed fifty-two colonies of Italian bees and forty-one nuclei devoted to the rearing of queens. The beekeepers in and

around the Raleigh, North Carolina area made it a point to call the school for help when they needed extra hands. This, in turn, helped the students to learn more from the surrounding apiaries. Nearly 150 students who registered had moved on to be successful beekeepers in different parts of the state.

Today, there are no known available government programs like the one that was offered by the Federal Board of Vocational Education. But there are a few beekeepers giving their help to veterans, and one of them is Bill Clothier, a thirty-year veteran of the United States Navy in North Carolina. He started Honey for Disabled Veterans with Rick Coor and Barry Jones. His program requests that local chapters donate the proceeds of their honey sold to the program. He raised $655 on Labor Day 2013.

In 1974, the North Carolina State Beekeepers Association successfully lobbied the North Carolina state legislature to create a full-time apiculture position at North Carolina State, and on February 2, 1975, Dr. John T. Ambrose began work as the extension beekeeping specialist. After a long career, Dr. Ambrose moved on in 2000 to become the dean of the first-year college at NCSU, and his former PhD student, Dr. Mike Stanghellini, ably served as the interim extension apiculturist.

Chapter 5

TO BEE DISEASED OR
NOT TO BEE...

The more common sources of failure to make a success at beekeeping almost always results from the lack of study of the needs of the bees, combined with failure to do things on time.
—E.F. Phillips

Bee disease, which can be contagious, includes, but is not limited to, American foulbrood (AFB), European foulbrood, Isle of Wight disease, varroa mites and tracheal mites. Yep, tracheal mites found in the bees' throats!

European foulbrood was first noted in America in 1894 in New York. This microorganism affects young brood, also referred to as larva (bees before they are born). More infectious is American foulbrood, which, prior to 1906, was not differentiated from European foulbrood. The disease was commonly referred to as just foulbrood. Both, though different, are diseases that affect the brood during development. The Wikipedia page on American foulbrood states, "American foulbrood spores are extremely resistant to desiccation and can remain viable for more than 40 years in honey and beekeeping equipment." Therefore honey from an unknown source should never be used as bee feed, and used beekeeping equipment should be assumed contaminated unless known to be otherwise."

Antibiotics are a common treatment used today, but many apiary inspectors require an American foulbrood diseased hive to be burned completely. Some beekeepers may take a less radical approach of containing the spread of the

disease by burning the frames and comb by flame scorching the interior of the hive body and its parts.

According to the University of Georgia (UGA), another tactic for preventing AFB and European foulbrood is biennial treatments of the antibiotic Terramycin. It is fed as a mixture in either powdered sugar, sugar syrup or in vegetable oil extender patties. For Georgia, UGA states, Terramycin treatments should be limited to the months of September and February. UGA also emphasizes the importance to beekeepers to never feed Terramycin to bees within four weeks of a nectar flow to avoid contaminating honey for human consumption. Lastly, it states that there is evidence in this country for bacterial resistance to Terramycin. For this reason, it is preferable to rely on sanitation and resistant queen stock for the management of this disease. However, UGA also says that Terramycin treatments in European foulbrood–infected colonies may actually be counterproductive because the medication permits those infected larvae to survive that would otherwise perish. These survivors then persist in the colony as a source of contamination. If the infected larvae are instead permitted to die, the house bees eject them from the hive, and with them go the source of infection.

The Bees Are Buzzing Off!

An article from CNN published on March 29, 2007, announced that beekeepers throughout the United States had lost between 50 and 90 percent of their honey bees over the previous six months, perplexing scientists, driving honey prices higher and threatening fruit and vegetable production. The article claimed that honey production declined by 11 percent in 2006 from the year before, and honey prices per pound increased 14 percent, from 91.8 cents in 2005 to 104.2 cents in 2006. Members of various organizations came together to share their concerns about what they were calling the Colony Collapse Disorder, or CCD. Beginning in October 2006, beekeepers from twenty-four states reported that hundreds of thousands of their bees were dying and their colonies were being devastated. Daren Jantzy, with the National Agricultural Statistics Service, told CNN that these statistics were based on numbers collected mostly before the true impact of CCD was noted. Its effect would be more noticeable when the 2007 statistics were collected.

A 2010 report from the USDA stated that colony losses remained at high levels, similar to the previous two beekeeping seasons. The USDA's

Agricultural Research Service (ARS) scientists and the Apiary Inspectors of America surveyed U.S. honey bee colonies and estimated total losses, from a variety of causes, to be more than 29 percent from the fall of 2008 through the winter of 2009. The 2009–10 data indicated a yearly loss of approximately 34 percent.

In a telephone interview, Gloria Hoffman from the USDA said, "One of the greatest sources of colony death is the weakening of the bees over the winter." She commented that most of the bees that die off every year, in the greatest numbers are just after winter. "The bees just are not fed enough to get them to spring," she said. Colony Collapse Disorder is a disease that is characterized by low numbers of adult bees and few signs of dead bees. Studies of the numerous possible causes for CCD have led researchers to conclude that the disorder may be caused by many different factors working in combination or synergistically. These factors may include a new parasite, management stresses and pesticides.

INSPECTIONS, INSPECTIONS, INSPECTIONS!

The first apiary inspection law in the United States was established in San Bernardino County, California, in 1877. By 1883, a statewide law was passed by the California legislature, and by 1906, twelve states had laws relating to foulbrood. At present, almost all states have laws regulating honey bees and beekeeping, designed primarily to control bee diseases. Therefore, they usually attempt to regulate movement and entry of bees, issuances of permits and certificates, apiary location, control and quarantine, inspection and methods of treating diseased colonies.

On August 31, 1922, Congress passed a law, popularly known as the Honey Bee Act, restricting importing living adult honey bees into the United States. This act was amended in 1947, 1962 and 1976. The last amended act in 1976 noted that in order to prevent the introduction and spread of diseases and parasites harmful to honey bees, and the introduction of genetically undesirable germ plasm of honey bees, the importation into the United States of all honey bees was prohibited, except that honey bees may be imported into the United States by the USDA for experimental or scientific purposes or from countries determined by the secretary of agriculture to be free of disease or parasites harmful to honey bees. The secretary may also determine honey bee semen to be imported as free of undesirable species

and subspecies of honey bees. As used in this act, the term "honey bee" means all life stages and the germ plasm of honey bees of the genus Apis, except honey bee semen. Any person who violated the act was guilty of an offense against the United States and shall, upon conviction, be fined or imprisoned for not more than one year, or both.

The North Carolina Department of Agriculture and Consumer Services Apiary Program's mission is to promote and protect the state's beekeeping industry. The Apiary Program provides disease and disorder inspections and fumigation services in an effort to control diseases and pests of the beekeeping industry. Additionally, this Apiary Program provides education to the state's beekeepers through workshops on the biology and treatment of mite and disease pests of honey bees and the notorious Africanized bees. North Carolina is divided into six inspection sections. There are roughly eighty dealers approved to sell or ship bees in North Carolina. Inspector report forms are on file for public record.

Effective as of April 3, 1990, in South Carolina, Act No. 395 states:

> *All bees and fixtures shipped or moved into this State must be accompanied by a certificate of inspection signed by the state entomologist, state apiary inspector, or corresponding official of the state or country from which the bees are shipped or moved. The certificate must certify to the apparent freedom of the bees and fixtures from contagious and infectious diseases and must be based upon an actual inspection of the bees and fixtures themselves within sixty days preceding the date of shipment. An entry permit from the Department of Plant Industry, Clemson University, is required before moving bees or fixtures into this State.*

The key figure in the enforcement of bee laws and regulations is the apiary inspector. He may have the entire state, a county or a community under his jurisdiction. His efforts are directed toward locating American foulbrood and eliminating sources of it whenever found. The effectiveness of bee laws and regulations is based on the compliance of the beekeeper. In addition, responsibility for disease control remains with the beekeeper, who should routinely examine colonies for disease as a regular part of his management program and do what is necessary when disease is found.

Chapter 6

THE HONEY BEES

Honey bees visit over two million flowers to make one pound of honey, flying a distance equal to more than three times around the world.

Honeybees are not native to the New World. North America has about four thousand native species of bees, but honey bees were brought to America in the seventeenth century by early European settlers. These bees were most likely of the subspecies *A.m. mellifera*, otherwise known as the German or "black" bee. This stock is very dark in color and tends to be very defensive, making bee management more difficult. One of the German bees' more favorable characteristics is that they are a hardy strain, able to survive long, cold winters in northern climates. Italian honey bees, of the subspecies *Apis mellifera*, were brought to the United States in 1859 in what would be an important milestone in American apiculture. They quickly became the favored bee stock in this country and remain so to this day. They were desired for their gentleness and storage of excessive amounts of honey. The superior merits of the Italian race of honey bees became known to a few leaders of American beekeeping, and they attempted to import queen bees from Italy. Accounts of these first efforts are confusing, but according to Pellet (1938), the first known successful importation of Italian queen bees was made in 1860. A few years prior to 1860, several attempts were made to bring Italian queens over by steamer, but all attempts failed until a man by the name of S.B Parsons, an agent for the U.S. government, purchased twenty colonies in

Italy. Ten of these were bought for the government and the other ten for himself. It was reported by Parsons that the government bees died, but a few were placed into the hands of a few beekeepers, notable among them L.L. Langstroth (more about him later).

Known for their extended periods of brood rearing, Italian bees can build colony populations in the spring and maintain them for the entire summer. They are less defensive and less prone to disease than their German counterparts, and they are excellent honey producers. They are very light colored, ranging from a light leather hue to an almost lemon yellow, a trait that is highly coveted by many beekeepers for its aesthetic appeal. Imported Italian queen bees were advertised for sale by L.L. Langstroth and Sons in 1866, but no prices were given. Those interested were advised to write for a price list. Just three years prior, in 1863, he was selling them for $20 each. At today's price, that would be roughly $300. Those queen bee prices moved down to about $1.50 to $2.25 by 1921 as they became more available. The average Italian queen sells for about $25 in today's market.

As queen rearing developed into a large-scale commercial enterprise in the southern states and Italian queens from Europe were used extensively in the breeding program, the strong, Italian-type bee dominated. Before the end of the 1920s, after years of persistent requeening with southern queens, northern beekeepers largely replaced the black bees with a less nervous, Italian-type bee that resisted European foulbrood.

Since 1886, queen bees have been sent to buyers via U.S Postal Service. This benefited both buyers and sellers, according to Pellet's *History of Beekeeping*. Losses in transit were reported from time to time, but on the whole, shipment by mail had been satisfactory. Post offices will accept either single queen cages or several cages stapled together. About one million queen bees are sent in the mail annually. Most of these bees are mailed to places in the United States and Canada, but some are sent to other countries.

According to the National Agricultural Statistic Service in 1980, there was an estimate of 200,000 people keeping almost five million colonies of honey bees and producing 200 million pounds of honey annually. Beekeepers receive income from the sale of honey, renting colonies for crop pollination, production and sale of queen bees and package bees that can be delivered by mail and, in a more minor role, the sale of beeswax, bee venom, propolis and royal jelly.

Here's a fun fact, according to Wikipedia: currently, only seven species of honey bees are recognized, with a total of forty-four subspecies. Honeybees

represent only a small fraction of the roughly twenty thousand known species of bees around the globe.

Between 1947 and 2008, honey bee colonies declined nationwide from 5.9 million to 2.3 million. Colony shortages were so critical that in 2005, honey bees were imported from outside the United States. The United States was forced to import these honey bees in order to meet its pollination demands. Dr. May R. Berenbaum, head of the Department of Entomology at the University of Illinois, said that "if honey bee's numbers continued to decline at the rates documented from 1989 to 1996, managed honeybees… will cease to exist in the United States by 2035." According to the 2007 Census of Agriculture, the number of bee colonies and pounds of honey collected increased between 2002 and 2007. In 2002, colonies of bees were recorded at 2,350,005 and 134,551,490 pounds of honey, with an increase in 2007 to 2,902,732 colonies and 152,057,812 pounds of honey.

Honey bees, as with any pollinator like the butterfly, play an important role in pollinating plants in the wildlife. Honey bees are important to South Carolina's agriculture. Cash receipts from cucumbers, watermelons, apples and cantaloupes—all of which depend on the honey bee for pollination—totaled $23 million in 1998. Many other crops grown in South Carolina depend on or benefit from honey bee pollination. In addition, the estimated annual value of honey bee pollination for vegetable and orchard crops produced by South Carolina home gardeners is another $20 million.

> *Gentle Bee! Bright example to mankind of industry, economy, concord, and obedience! What triumphs, what wonders, dost thou not achieve! It shall be our delightful task to talk of thee, and to write of thee; then indeed the fault is in ourselves, and not in thee. Sweet is the sound of the morning hum, attuned to music, when thou revellest on some gay bank purple heather visiting bell after bee in quest of their ambrosial essence, heaven distilled! Sweet is the air around thee, air impregnated with the breath of flowers! Sweet is the joyous concert of feather choristers above and about thee! Sweet is the memory of those few happy days when we have drank freely of scenes like these and basked in the early sunshine on some fragrant bed of thyme, "dazzled and drunk with beauty"—the beauty of nature.*
>
> —The Honey Bee, *by Edward Bevan, circa 1835*

The Honey Bees' Needs

The book *Honey Bees and Honey Production in the United States*, written in 1918, reports that due to severe storms, the loss of colonies of bees during the previous winter was 18.7 percent of the total colonies, which roughly translates to one in every five colonies. These losses were due to one-third freezing and another third starving, and this was looked upon as the fault of the beekeepers. This amount across the nation can be assumed to produce twenty to thirty million pounds of honey. Most of these losses were in the northeastern states as far south as North Carolina. Other causes of loss were failing queens and late season swarming.

African bees were brought to Brazil in 1956 by a bee expert who hoped to increase honey production through a crossbreeding program with the European honey bee. In 1957, twenty-six swarms headed by African queens were released accidentally, and these hybrid descendants have since migrated to North America.

The South Carolina Africanized Honey Bee Advisory Committee was formed in April 1989. The committee was established due to the bee's potential impact on our beekeeping and livestock industries, elevated public health concerns and essential pollination for the South Carolina agricultural industry. The committee consists of fourteen members selected from various state agencies and associations that could either be directly impacted or who have a potential role to play in education, health or management of the Africanized honey bee (AHB) once it reaches South Carolina. The advisory committee formulated the South Carolina Africanized Honey Bee Management Plan, which incorporates the best possible strategies for dealing broadly with the problem, based on the best current technology, when it arrives in the state. The plan lists recommendations in five areas: education, training and public information; regulatory and quarantine; public health; a management plan for South Carolina beekeepers; and control and identification. According to Michael Hood, who worked as an extension entomologist and professor in the Department of Entomology, Soils and Plant Sciences at Clemson University, states that the offspring of these "mis-matings" defended their nests more vigorously than European bees and swarmed more often. Therefore, they were better suited for survival in the tropics. Researchers named them Africanized honey bees. However, as a result of widely publicized stinging incidents, the name "killer bee" was used in the media.

Chapter 7

HONEY

Honey is, essentially, bee barf. Nectar from flowers is collected by the honey bee through its mouth using its proboscis and placed into its honey stomach, separate from its eating and digesting stomach. Once inside the bee's stomach, the sugary nectar mixes with enzymes to convert from sucrose to fructose and glucose. It is then carried back to the hive and regurgitated to the worker bees waiting inside. The worker bees will then place the liquid nectar into an empty honeycomb cell. While adding honey into the cell, the worker bees fan the honey to evaporate the water from the honey to about 17 percent humidity. It is then ready to be capped with beeswax. Honey is a natural preservative that does not allow bacteria to grow in it, so long as water has not been introduced to it. The average honey bee makes roughly one-twelfth of a teaspoon of honey in her lifetime. Only the female bees forage and collect nectar and pollen, while male bees (also referred to as drones) hang around in and out of the hive hoping and waiting to one day mate with an unfertilized queen.

The National Honey Board notes that a tablespoon of honey contains sixty-four calories. Raw honey is not only a sugar substitute, but it also contains protein, trace vitamins and minerals, including vitamin C, vitamin b-6, niacin, calcium, potassium, sodium, zinc, phosphorus and iron and enzymes. Raw honey is unadulterated, unprocessed, unpasteurized and unfiltered. The best raw honey may contain a few bee parts, flecks of pollen and sometimes chunks of comb.

The average pH of honey is 3.9 but can range from 3.4 to 6.1. Honey contains many kinds of acids, both organic and up to eighteen of the twenty amino acids and minerals. However, depending on the type of honey, the amounts of these materials may vary considerably. Honey contains about 69 percent glucose and fructose, enabling it to be used as a sweetener that is better for your overall health than normal white sugar. It has been said that though honey has more calories than sugar, it helps in digesting the fat stored in the body. Honey and lemon juice, as well as honey and cinnamon, have also been recorded to help in reducing weight.

Crystallization of honey occurs when the honey varietal is higher in glucose percentage. Tupelo is prized for not crystallizing, as it is very low in glucose. The crystals in crystallized honey are the glucose grains in a fructose mixture. Simply reheating crystallized honey in a warm bowl of water will return it to its liquid state.

The National Honey Board also states that the consumption of honey in the United States is approximately 1.3 pounds per capita per year. Individual consumers who purchase small amounts of honey contribute significantly to overall consumption in the United States. The World Trade Daily website reports that in 2010, the United States was one of the world's largest producers of honey; it is also the second largest importer. We buy more honey than the largest exporter of honey—which in 2010 was China—sells, exporting $284,064,882 worth of fine liquid gold. This comes as a bit of a shocker after seeing the documentary *Silence of the Bees*. Chinese pear farmer Cao Xing Yuan was interviewed for this U.S. documentary. Ever since bees in his region of Hanyuan County were wiped out by pesticides twenty years ago, he and his neighbors have had to carefully dust pollen onto each pear blossom. It is a slow, laborious task involving the transfer of pollen with a cotton ball or artist's brush from male to female flowers. Sometimes the corolla is removed from male flowers and the flower itself is brushed against the stigmas of female flowers. Now isn't that sexy! But this area of China is small compared to the entire country. If humans were to replace bees as pollinators in the United States, the annual cost has been estimated to be a cool $90 billion!

The United States has a unique and diversified honey import profile. The United States imports 19 percent of its foreign honey from Argentina, spending an estimated $54 million in 2010. Vietnam was the second largest source, accounting for 16 percent, for an estimated $47 million. The United States is one of the world's largest markets for industrial honey, meaning honey that is used in bakeries, health food and cereal.

A roadside honey stand in North Carolina. *Courtesy of Special Collections Research Center, North Carolina State University Libraries, Raleigh, North Carolina, ua023_007-001-bx0002-002-009.*

In 1859, the United States Department of Agriculture recorded that the amount of honey produced in South Carolina was 526,077 pounds, Georgia was 953,915 pounds and North Carolina was a whopping 2,055,969 pounds. In 2012, Georgia produced 3,009,000 pounds and North Carolina declined in its production to roughly 380,000. North Dakota overshadows all states with 33,120,000 pounds.

WHO'S KEEPING THE HONEY BEES?

The industry is divided into three types of production: the hobbyist, the part-time beekeeper and the commercial beekeeper. Hobby-sized operations are categorized as those with twenty-five colonies or fewer; hobbyists with fewer than five colonies are not included in the colonies reported by the USDA. Part-timers are those with twenty-five to three hundred colonies, and commercial operations are those with more than three hundred colonies. Hobbyists and part-timers account for roughly 40 percent of the honey production, and 1,600 commercial beekeepers are responsible for the remaining 60 percent of production.

Approximately a dozen large commercial honey packers process over 50 percent of the domestically prepared commercial honey. The balance of the domestic production is processed, packaged and sold by smaller firms or individual beekeepers. With more than three hundred members in more than thirty states, Sioux Honey Association is the leading packaging cooperative and processes approximately forty million pounds of honey annually in its three locations, one of which is in Elizabethtown, North Carolina. Almost one hundred years ago, five beekeepers near Sioux City, Iowa, joined forces and formed Sioux Honey Association. With shared equipment, processing facilities and marketing, Sue Bee Honey was developed. Sioux Honey markets its products globally under the following labels: Sue Bee, Clover Maid, Aunt Sue, Natural Pure and North American brands.

The color of honey depends on the source of nectar that was visited by the honey bee and will range from a very pale yellow to amber to darkish red amber to nearly black in color. The variations are almost entirely due to the plant source of the honey, although climate may influence the color somewhat through a darkening action from heat. The flavor and aroma of honey vary even more than the color. Although there seems to be a common characteristic of a "honey flavor," almost an infinite number of aroma and flavor variations can exist. As with color, the variations in flavor appear to be dominated by the floral source. In general, light-colored honey is milder in flavor and a darker honey has a more pronounced deeper flavor.

Before the invention of the honey extractor, honey was either squeezed or pressed from the comb or produced as comb honey. It was easier to entice bees to build comb in small, conveniently sized boxes or sections rather than to cut up combs. These sections were approximately $4\frac{1}{4}$ by $4\frac{1}{4}$ inches and held about a pound of honey.

The term "section" is used here to describe the small wooden frames in which honey is produced. The production of section honey is, to coin the phrase, "the fanciest product in the art of beekeeping." Section honey was first produced in the 1820s. The crude method of section honey production was gradually abandoned as more and more beekeepers began to use movable comb hives. The large homemade section boxes were replaced with smaller, factory-made ones. Hive frames were developed especially to hold the sections. Before World War I, beekeeping supply companies sold forty-five to fifty-five million sections annually. Section comb honey was very popular and shipped regularly in railroad car lots during the early 1900s.

In an 1897 article for *Gleanings in Bee Culture*, C.F. Muth writes that honeycomb sections transported by rail arrived in perfect condition and that they can be

shipped safely if the railroad employees handle the loading and unloading like cases of eggs. It has become notoriously known that comb honey can be damaged while being loaded on the cars and unloaded at arrival. Comb section honey was desirable to the public because they knew what they were paying for was not adulterated honey, and at that time, many newspaper articles were scaring the public into believing that the honey they purchased in liquid form may not be pure 100 percent honey. The comb honey gave them reassurance, as it was still on the comb and hard to adulterate.

Production of section honey required a heavy nectar flow of several weeks' duration and a great deal of hand labor for cleaning, weighing and grading. In addition, beekeepers were unable to provide the intensive colony management needed in out yards (bees kept in remote locations) miles from their homes.

The Pure Food Law of 1906 gave buyers more confidence in the purity of extracted honey, thereby increasing demand for it. During the sugar shortage period of World War I, the demand for honey increased, and as the price was high, production of extracted honey increased rapidly. The amount of section honey produced declined rapidly after World War I because the product was fragile and difficult to ship; combs were likely to leak or granulate.

Large amounts of liquid honey were shipped in wooden barrels in the last part of the nineteenth century. Then the sixty-pound metal can came into general use. Today, most bulk honey is sold in fifty-five-gallon steel drums.

Blue as the Carolina Sky

Have you heard of the blue honey found in North Carolina? In an article, "The Mystery of Blue Honey," Allison Perkins writes that Bill Shepard began seeing blue honey in his hives and thought it was bees foraging in the huckleberries growing nearby. But North Carolina State University professor John Ambrose performed a series of tests in the 1970s to pinpoint the source of the blue honey. The result: nothing is what it seems. In his study, he found that the honey bee forages and collects nectar in the sack in its belly called a honey stomach, meant for carrying nectar back to the hive. When Ambrose field-stripped bees in his study, the bees arriving at the blue honey hives never had blue in their stomachs, but the bees leaving the hive did. Ambrose says, "That tells you something is happening to the nectar after it reaches the hive to change the color." So he did more tests. He collected as many

blue flowers and plants as possible and soaked them overnight in the juices of the bees' digestive tracts. By morning, the goo surrounding one specific flower, the sourwood, was tinged blue. He found higher aluminum content in some of the blue flowers. Specifically, flowers on the Coastal Plain were slurping more aluminum out of the soil than in other places around the state. In the hive, that aluminum content reacts with the acidity being added by the house bees as they turn the nectar into honey. The amount of acidity, Ambrose believes, plays a role in creating blue honey. The true source of this bluish purple honey is still debatable.

HONEY AS MEDICINE

Ambitious drugs made with chemicals made the use of honey as a medicine fall out of favor during World War II. But honey is making a comeback with its well-known old ways of healing by being added back in to cough drops and cough syrup, cosmetic supplies and hair treatments.

Honey prevents deformity of the skin on the surface of a wound by creating a moist healing environment that allows skin cells to regrow. Honey, with its acidic pH, acts as an antiseptic agent, promoting an antifungal and antibacterial environment to help disinfect and speed the healing process in scrapes, burns, skin ulcers, boils and abscesses. During the Civil War, nurses and doctors would apply honey to protect against infection and promote healing.

Apitherapy is the term used for healing with use of honey bee products such as bee pollen, bee venom, propolis, honey and royal jelly for medicinal purposes. In North America, there is no specific training or license required for practitioners of apitherapy. In many instances, apitherapy is practiced by naturopaths, acupuncturists, nurses and physicians.

Some of the uses of apitherapy are for rheumatoid arthritis, osteoarthritis, multiple sclerosis (MS) and pain after a shingles infection. It is also used for cough, premenstrual syndrome (PMS), herpes simplex virus, hay fever, high cholesterol and the common cold. Ever hear someone tell you to eat local honey for seasonal allergies? Bingo. The pollen grains from local plants and flowers find their way into the nectar and eventually into the honey. Ingesting a tablespoon of local honey every day boosts your immune system and provides greater resistance to the allergens produced by local flowering plants. If it works, then great! And if not, at least you had a delicious spoonful of honey.

The use of different products from the hive is thought to have different actions in and on the body. In 1888, Dr. Phillip Terc published results in "Report about a Peculiar Connection between the Bee Stings and Rheumatism," in which he notes specifically the use of bee venom as a treatment for arthritis. Bee venom is noted to be a rich source of peptides, biogenic amines and enzymes. It is thought to decrease pain and swelling, although some studies have disagreed. Practicing healthcare providers and apitherapists follow certain protocols when administering treatment. Therapy usually starts with determining whether the patient is allergic to bee venom by administering a very small amount of the bee venom intradermally (just between the skin layers) or subcutaneously (under the skin) to mimic the effect of a real bee sting. The therapy is continued if no reaction develops. Every other day, the therapy is carried out gradually with one or two bee stings or injections. Traditionally, live bees will sting the affected acupuncture points or trigger point areas with their venom. Depending on the disease that is being treated, bee venom can be used in cream, liniment, ointment or injection form. The injectable form of venom is most commonly used, although venom from a live bee is the most potent source of venom.

Steven Coradini of North Carolina, in his testimonial on the website of the American Apitherapy Society Inc., writes about the benefit of bee venom therapy for his back pain:

> *1999 was the year that would change my life forever. After being a funeral director and an embalmer for 17 years, one day I woke up not being able to shut off my alarm clock because I had no feeling to my hand. After some medical tests and an MRI I learned that I had a ruptured disc in my cervical spine along with a herniated disc in my lower back. The journey that I would take over the next several years included 5 cervical surgeries, one lumbar surgery along with the placement of an intrathecal pump for chronic pain as well as plenty of physical therapy. Due to the repetitive surgeries along with my initial injuries I have been left permanently disabled with daily chronic pains. The intrathecal pain pump that was implanted in my abdomen and connects directly to my spine, helps cut the chronic pain but doesn't eliminate all of the pain. Now to fast forward to 2010: I am still disabled, but wanting something to do, I decided to learn how to become a hobby beekeeper. Well part of my beekeeping process was to join the Mecklenburg County Beekeepers Association as well as the North Carolina State Beekeepers Association, which is where I attended the State meeting on*

March 5 & 6, 2010. During that weekend state meeting there were several key note speakers but the one who sparked my interest over the others was on the topic of "Apitherapy" by Frederique Keller, L.Ac. Her presentation was amazing and I couldn't wait to attend her practical workshop because I was riddling in pain since my intrathecal pain pump had stopped working all together a week before and I was waiting for it to be replaced. In the meantime, I was given oral painkillers which barely touched the pains that I was feeling. So after Frederique finished her lecture, I approached her at the stage to ask if it would be possible to receive some Bee Venom Therapy and she said that she would gladly try to help me. As we walked to the classroom where the workshop would be, I had discussed my past medical history with her and she assured me that I would be getting some relief with Apitherapy. As the workshop began, Frederique asked me to come to the front of the classroom, which was filled with beekeepers, and asked me to give my medical history to everyone. As I took off my shirt, it was obvious from the scars on my spine and back that I had been through many surgeries. Since I had only been stung once the year before by a honeybee, it was important that I received a test sting to make sure that I wasn't allergic to it. I passed that test with flying colors. So after 5 minutes, I was asked where I hurt the most. I responded that I am in extreme pain from the small of my back and down both legs. Frederique then stung me on the right side of my spine at the level where I would wear my belt. I felt the pinch and then the burning of the venom. But within 5 minutes, I had no pain in the small of my back or any pains down my legs. I wouldn't have believed it if I had not experienced it myself. I did get another sting at the top of my buttocks because I still had pains running through my pelvis and again within 5 minutes, those pains were gone. I was advised to get bee venom therapy 2 to 3 times a week as well as mini stings on the multiple scar lines on my back to improve my quality of life. I assured her that it wouldn't be a problem since my friends and I are beekeepers and are willing to learn more about apitherapy. I have since spoken with Frederique days after the workshop and informed her that I was pain free for 10 to 12 hours. She was surprised that I had gotten relief for such a long time but was glad I did and even offered to treat me whenever I come to visit family on Long Island.

Honey is sometimes applied directly to the affected area for burns and wound healing. A comparative study written in the *Indian Journal of Plastic Surgery* (2009) evaluated the effects of a honey dressing and silver sulfadiazine dressing (SSD) on wound healing in burn patients. It revealed

that the honey dressing decreased the average duration of healing as compared to the SSD cream and that honey was reported to cause no tissue damage and appeared to actually promote the healing process. Also within twenty-one days, the dressing with honey became sterile after a culture test was taken, and the SSD-treated wounds achieved only 36.5 percent sterility. The conclusion on this report is that honey dressing improves wound healing, makes the wound sterile in less time and has a better outcome in terms of prevention of hypertrophic scarring, post-burn contractures and the need of debridement.

Propolis, also referred to as "Russian penicillin" or "bee glue," is a sticky substance that bees make from plant and tree resins. Bees use it in their hives to seal up cracks or mummify unwanted wasps or other creatures that may decay inside, fighting off bacteria and viruses that would be detrimental to the well-being of the colony. Propolis from different regions of the world will exhibit slightly different properties from the different tree and plant resins in that area. This sticky resin used for humans is known for its anti-inflammatory and antioxidant activity and is known for regenerative effects as well as tissue strengthening. In countries where antibiotics are not easily available, propolis is a common method to heal a variety of wounds. Propolis can be found in tincture form and applied to the skin. As an antiseptic wash or salve, propolis is able to prevent the growth of bacteria in cuts. Used as a mouthwash, it has also been used to prevent gingivitis, tooth decay, bad breath and gum disease and is commonly taken as a remedy for sore throats. In conjunction with royal jelly, it can ameliorate the side effects of chemo and radiation therapies. However, there is not a lot of scientific information about it.

Royal jelly does not refer to something the queen of England spreads on her toast in the morning but, instead, a milky substance that is fed to a queen bee cell exclusively throughout her development. This product is what makes the difference between a basic worker bee and a queen bee. Nurse bees caring for the larvae will produce it using their hypopharyngeal and mandibular glands between their fifth and fifteenth days of age. All bee larvae are fed royal jelly for the first three days after the queen lays the egg. The designated new queen bee cell will continue to be fed the royal jelly while other bees only receive honey. The components of royal jelly help the queen mature into a large, fertile and longer-living bee that will live for several years, while worker bees, during the active part of the summer, live from four to six weeks. This is due to royal jelly's powerful effects on the bee's hormonal, metabolic and endocrine systems.

Royal jelly is a wonderfully prized commodity in many cultures, most notably in Chinese medicine. It is used today for a wide variety of conditions including anxiety, asthma, fatigue, menopausal symptoms, blood pressure and a variety of skin conditions. Royal jelly, which is high in B vitamins, has a metabolic stimulating action, which aids in the processing of proteins, carbohydrates and lipids. Also referred to as the fountain of youth, it is a powerful antioxidant; royal jelly decreases levels of free radicals, which are linked to aging. Royal jelly has also been determined to promote collagen synthesis and is beginning to be found in many topical dermatologic products.

BEESWAX

In an article written in 1942 during World War II, G.H. Cale quotes an official in the office of price administration who calculated that there are approximately 350 uses for beeswax in the navy and army and about 150 uses in the pharmaceutical field. Some of the uses were to waterproof canvas tents and belts and metal casings of bullets, cables and pulleys. In a *Newsweek* article, the War Food Administration urged beekeepers to conserve every bit of beeswax, as it was needed as a war product in 1942–43.

Throughout history, wax has been used in huge quantities for candles in churches. Wax in churches was considered a symbol of the virgin body of Christ because the bees carried the wax from the flowers. The wick denoted the soul or morality of Christ, the light that burns bright. Aristotle stated, "We must no more ask whether the soul and body are one than ask whether the wax and the figure stamped on it are one." Because of the powerful symbolic religious purity, churches were the biggest consumer of wax in the world. Beeswax candles were especially high in demand for religious ceremonies like Henry V's funeral parade in 1422 that stretched two miles long and was illuminated with beeswax candles. All the abbeys and monasteries had their own apiaries. Many of the peasants had hives of their own, and if they owned land under the monastery, they had to pay a yearly rent in wax. Under all levels of society from the rich to the poor, any gifts, goods, taxes, fines or rent could be paid for in wax. Some folks even stamped coins out of wax and used them in their trade.

Before the Reformation, the church of Wittenberg used thirty-five thousand pounds of beeswax over the course of one year. After the religious revolution of the Reformation in Europe that started when the German

monk Martin Luther questioned the Catholic Church in 1517 with his Ninety-five theses, the need for candles was curtailed. The illumination of light was only for the church, royalty and the very rich. Queen Elizabeth in 1580 passed an act for the true making of pure beeswax that harshly punished wax makers for adding animal fat or stones to the weight of the wax bricks and required the merchants to mark, emboss or stamp their own products with their initials to guarantee purity.

Beeswax soon became an article of commerce available in the American colonies. It was widely used in candles at home and abroad. The wax was melted, poured into molds and then transported to markets. North Carolina in 1740 and Tennessee in 1785 permitted taxes to be paid in beeswax because of the shortage of money. Information is not available about how much beeswax was produced or used in the colonies in the 1600s and the first part of the 1700s. But it has been recorded that beeswax was an article of export in the eighteenth century, particularly from the ports of Philadelphia, Charleston, Pensacola and Mobile. In 1767, a total of thirty-five barrels of beeswax were exported from Philadelphia, and 14,500 pounds were exported from Charleston in 1790. Beeswax was listed in articles exported from the British Continental Colonies in 1770: "Value 6,426 pounds sterling; 128,500 pounds weight; 62,800 pounds to Great Britain; 50,500 pounds to Southern Europe; 10,000 pounds to Ireland; and the rest to the West Indies and Africa." Honey was not mentioned.

Just as bees use wax for the interior of their homes, so did humans. People used it to cover cheese, polish floors or cover leather, which made the surface suppler, stronger and even weatherproof. This waterproof wax was also great for covering boats. Aside from preserving boats and bodies, it made a great medium to form sculptures and preserve likenesses that may have been more difficult to re-create using wood, clay or gold. Encaustic art grew from just adding pigment to surface to the invention of crayons only a century ago. C. Harold Smith and his uncle Edward Binney were both in the paint business in Pennsylvania and began to experiment with beeswax and other petroleum-based materials to produce a colored wax stick. In 1903, they created a box of eight rainbow crayons. Edward's wife coined the term "Crayola" by combining the French word *craie*, which means chalk, with the word *ola*, a shortened word that is also "oleaginous" or oily.

Chapter 8

GEORGIA

If success lay in the path of everyone who entered beekeeping, ours would soon be a crowded business.
—*J.J. Wilder*

The State of Georgia designated the honey bee as its state insect in 1975. This was to acknowledge and credit the honey bee's contribution to its economy and of honey production and aiding pollination of more than fifty Georgia crops. Georgia Tech's mascot, not to be confused with a honey bee, is a yellow jacket named Buzz that showed up with school spirit in 1972.

In 1878, the Georgia State Agricultural Society estimated 77,135 colonies of bees in the state of Georgia which equates to one and a fraction for each square mile. At the same time in Europe, the number of colonies of bees was greatly more abundant per square mile. In the province of Lunenburg, Germany, there were 144 hives per square mile, and in the province of Attica, Greece, there were 44 hives. Most notable is Holland with 2,000 colonies per square mile. No wonder that country has so many beautiful flowers!

White tupelo of the Apalachicola, Chipola and Ochlocknee rivers is one of the blooming sources that bees love to forage on for the short duration of only two to three weeks. Tupelo trees have clusters of greenish flowers that later develop into soft, berrylike fruits. In southern Georgia and northern Florida, during the months of April and May, tupelo is a leading honey plant that produces extra light amber, very mild, smooth honey. This honey

is said to be the only honey that does not granulate. A very skilled beekeeper knows how to collect this honey exclusively as so not to allow the bees to add other collected nectar sources back into the hive along with it. Black tupelo honey will granulate and is darker in color. Beekeepers have to strip their hives immediately before allowing the bees to forage on White Tupelo. Other flowering plants in this region include gallberry, locust, huckleberry, partridge pea, prairie clover and titi white holly. Sourwood blooms from June to July and is a very delicious honey that is extra light to light amber in color and does not granulate easily.

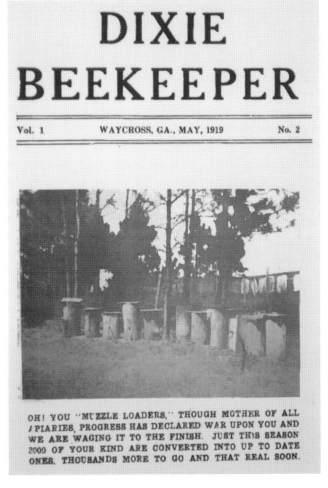

The cover of *Dixie Beekeeper*, published by J.J. Wilder in Waycross, Georgia. *Image scanned in the North Carolina University Library.*

J.J. Wilder published in the *Dixie Beekeeper* in July 1922 an article about white tupelo gum (male), sometimes called cotton gum or Ogeechee lime and cork gum because when the roots dry out they are as lightweight as a cork. Interestingly, the females yield large amounts of nectar but not so much as the males since the male tupelo bears the burden of the blossoms. It is believed that in the years 1750 to 1760, the seed of this tree was brought over in slave ships. Wilder writes, "The colored slaves brought seeds of every kind to plant in the new country where they would not expect to find here. Along the Ogeechee River it is reported that the African slaves in Bulloch and Effingham counties, by Savannah, Ga., that it was here that the White Tupelo Gum was first discovered. So the black man was responsible for the introduction of this famous and great honey plant."

Before 1922, the poplar or tulip tree was the greatest source of honey in Georgia. The lumberjack needed a larger tree; they chopped down what they could all over the country. Sourwood was in abundance too but scaled down to just the mountainous ranges.

It's not how far you fall but how high you bounce that counts!
—Zig Ziglar

When a new beekeeper loses his first colony, there is a grieving process that accompanies it. To explain this more sentimentally, it's a dark mourning of a thousand deaths. Whether the bees swarmed or were overrun with disease—like an invasion of the wax moth, attack of the hive mites or out-of-control immigration of the hive beetle—one can't help but feel responsible and a bit hopeless to one day become the great beekeeper he believes resides inside him. For the grief-stricken, the following year will either be a new start for the empty hive or a raging approach toward better success with starting up several hives. In his book *Southern Bee Culture*, J.J. Wilder writes that he was one such beekeeper living in Georgia at the beginning of the 1900s. He believes that his interest in bees grew as a child while traveling in an ox-driven wagon across Texas. He explains that the height of joy in his boyhood days was riding around with bee hunters, finding hives in trees and cutting them down. This idea of seek and find may prompt one to believe that perhaps the prehistoric man sought out the beehive in nature with the same joy and excitement.

As he got older and moved on from just looking after bees for others, Wilder established an old-style box apiary with just a few colonies. The young man would spend his leisure time at high noon under a shady mulberry tree doing

all he could to help the bees. Life on the farm was charming. He kept a few colonies that would die back but never leave completely until one spring he had only one hive left that succumbed to the wax moth. All the inspiration that the hives gave to the farm was lost. So the young man went into the forest, sat next to a tree and cried his eyes out over the death of his last colony. At that moment, he decided that if he ever had another start at keeping bees, he would give them better attention. And so he did. J.J. Wilder grew to be one of the biggest beekeepers in America. In 1920, it was reported that he had ten thousand colonies in 150 different apiaries scattered from Cordele, Georgia, to the high ridges of Florida. All the colonies were cared for by a small army of helpers. His success was greatly credited to the region of the country. He was referred to as the "Dixie Beekeeper" and the "Georgia Bee King" by F.M Baldwin of the *Beekeepers' Review* in 1921. Wilder, who started out poor, saved every dollar that he could and put it into more hives. His hives and equipment were worth a good fortune.

Several years had gone by since that final colony loss, and Wilder still only kept a lookout for others' bees until one day, as a reward from one of the hive owners, he was given a colony. At the time he was given his new hive, he had not used or seen a patent removable frame system. Wilder outfitted some old crude frames and began business once again. He later visited a beekeeper who had been using the factory movable frame hives and decided it was time to buy some. So he bought a lot of them. He endured ups and downs growing his apiary in the Cordele area of Georgia. Wilder knew that bee culture was his calling, so he applied himself to learn everything he could about bees and kept a close and constant watch on them, traveling around the South investigating honey plants.

T.W. Livingston from Norman Park, Georgia, was referred to as the Langstroth of the South, as he had more of an inventor nature of bee culture than a writer on the subject. From the image of him, he may have been mistaken as Colonel Sanders (albeit the bucket of chicken is cropped out of his photo). He had several inventions to his credit, including the reversible honey extractor. And though he was not a preacher like Langstroth, he was a good and religious man with a deep knowledge of history and philosophy. He moved to Dalton, Georgia, in 1888 and found it to be a beekeeper's paradise. He had heard that in the south of Georgia, in the great gallberry region, a honey crop had never failed. So he eventually landed in Leslie and remained there for twenty-three years without a single crop failure.

A few years after he had settled in Leslie, a young man from Cordele came to see him about bees. The young man was starting in the business and wanted

T.W. Livingston, instructor and advisor to J.J. Wilder. Wilder credits him for his success as a beekeeper. *From Wilder's System of Beekeeping.*

to know about bees. That youngster was J.J. Wilder. Livingston advised him that the difficulties in the bee business must be understood. He paid special attention to the trees and stated, "I know that tall oaks from little acorns grow; but a slight accident to the sprouting acorn or young sapling might ruin the prospects of the future trees, so who could predict the future of the acorn to the man? All oaks start from acorns and all men, great or small that start from humble beginnings may now become great without having surmounted many difficulties."

Truly the honey-bee is worthy of the title, the most industrious of all living objects.
—*J.J. Wilder,* Southern Bee Culture, *1908*

In the *American Bee Journal* in April 1912, beekeepers from around the country could correspond with a column written by Wilder. One of the questions asked was about bulk-comb honey (honey still on the comb but not like the uniformed section comb). The writer wanted to know what kind of honey he should pack it with and what style package he should use. Wilder responded that he chose his lightest-colored honey and packed it in a pint or quart Mason fruit jar, which was easily obtained from the local market.

Wilder later became the president of the Georgia Beekeepers Association in 1920 and was also owner of the *Dixie Bee Journal,* a thirty-two-page monthly publication that sold for one dollar a year and ran from 1919 to 1921. In 1918, he was president of the Tupelo exchange.

M.L. Nesbit of Bainbridge, Georgia, was interviewed in the *Post-Searchlight* paper in 1921. He was an enthusiast and successful beekeeper and could convince any outdoor-loving person that he, too, could be a beekeeper. Nesbit had been piloting boats up and down the Flint River. He believed

Left: Honey dripping into a wine glass. *Photo by Chrys Rynearson.*

Below: The gift shop at Bee City sells honey, beeswax candles and all kinds of fun hive-related items next to its café. *Photo by Caleb Quire.*

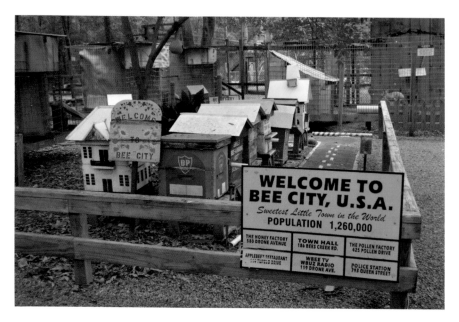

Sign of welcome to Bee City. *Photo by Caleb Quire.*

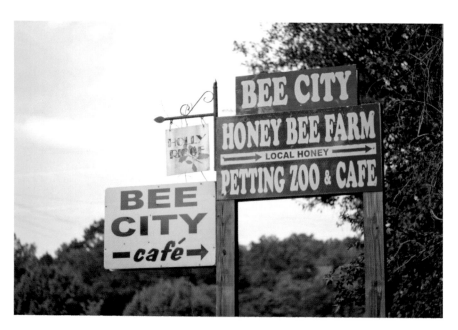

Bee City sign in Cottageville. *Photo by Caleb Quire.*

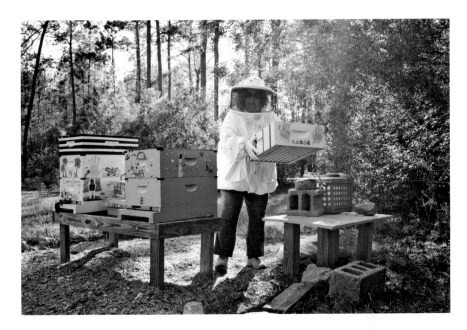

Above: Devorah Slick in her bee
yard in Mount Pleasant, South
Carolina. *Courtesy of Jonathan
Boncek.*

Right: A gallon of fermenting
mead. *Photo by Chrys Rynearson.*

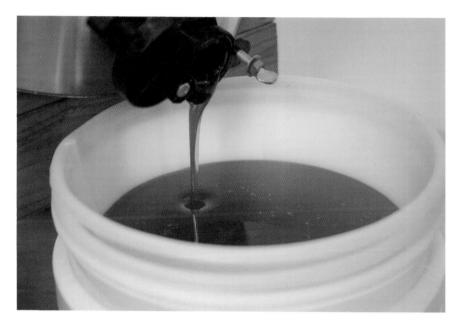

Honey dripping into a bucket. *Photo by Caleb Quire.*

Putting honey frames into the extractor with Larry Haigh in his honey house in Mount Pleasant, South Carolina. *Photo by Caleb Quire.*

Empty frames after honey extraction. *Photo by Caleb Quire.*

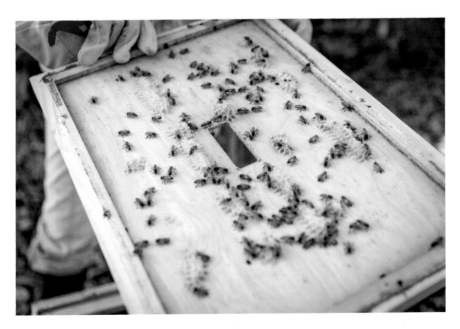

The inner cover with bees on it. *Photo by Chrys Rynearson.*

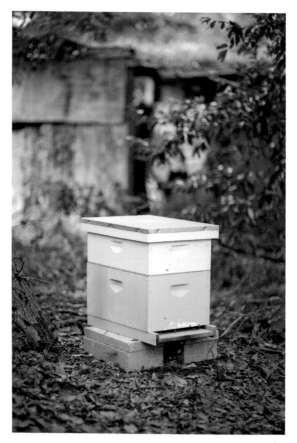

Beehive. *Photo by Chrys Rynearson.*

Bees on frames inside the hive. *Photo by Chrys Rynearson.*

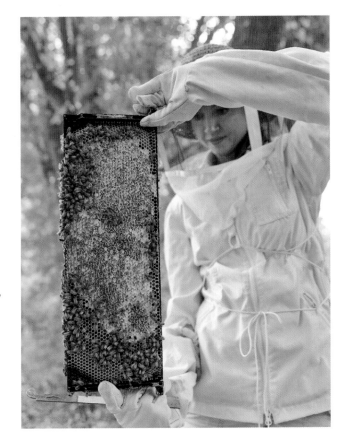

Right: A typical beehive examination, looking for pesky hive beetles and determining the health of the colony. *Photo by Chrys Rynearson.*

Below: A smoker "smoking." *Photo by Chrys Rynearson.*

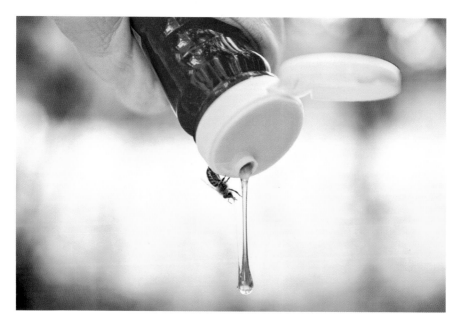

A honey bee stealing from the honey jar. *Photo by Chrys Rynearson.*

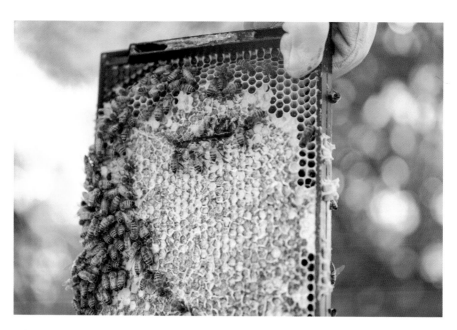

A frame of capped honey. *Photo by Chrys Rynearson.*

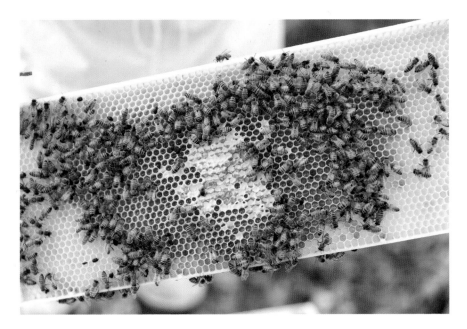

Bees on a frame. *Photo by Chrys Rynearson.*

A healthy frame nearly capped full of honey. *Photo by Chrys Rynearson.*

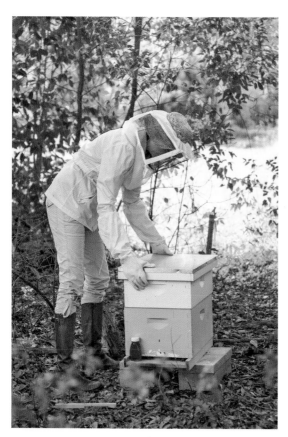

Left: This beehive is kept in Summerville, South Carolina, next to a small farming field. *Photo by Chrys Rynearson*.

Below: Pulling out a frame of honey. *Photo by Chrys Rynearson*.

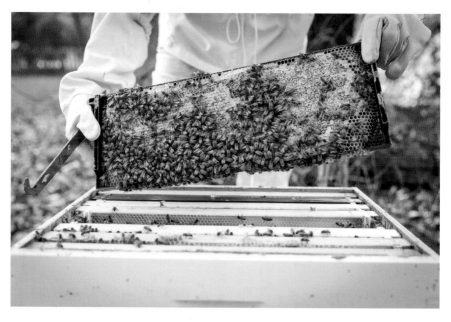

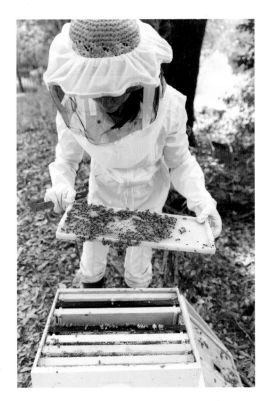

The author reaching into the hive for a frame. *Photo by Chrys Rynearson.*

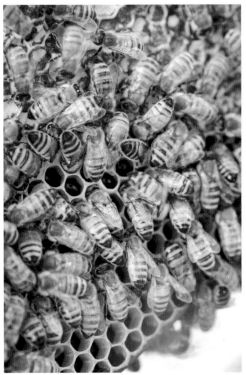

A close-up of bees. *Photo by Chrys Rynearson.*

Lighting up the smoker can be a little tricky. Pine straw and a little newspaper usually do the trick. *Photo by Chrys Rynearson.*

A honeybee in a glass of honey. *Photo by Chrys Rynearson.*

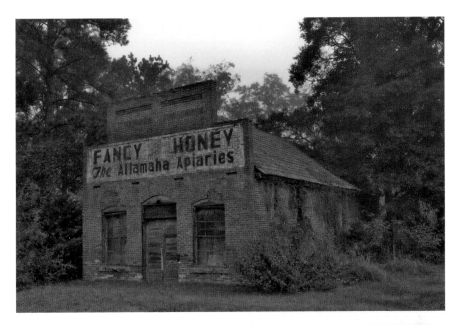

Above: Fancy honey at the Altamaha Apiaries in Gardi, Georgia. *Photo by Brian Brown.*

Right: Future beekeeper Logan Ridley learning about honeybees. *Photo from the author's collection.*

Above: Beekeeper Justin Ridley with his backyard hive in Summerville, South Carolina. *Photo from the author's collection.*

Left: Heather Mathis-Faas holding up a frame full of capped honey at her home in South Carolina. *Photo from the author's collection.*

Heather Mathis-Faas teaching her daughter Peyton and friend Logan a little beekeeping 101. *Photo from the author's collection.*

A honey bee on fresh-cut honeycomb. *Photo by Chrys Rynearson.*

Photos by Chrys Rynearson.

Right: J.J. Wilder in the early 1920s. *From Wilder's* System of Beekeeping.

Below: An advertisement for J.J. Wilder Bee Supplies in Waycross, Georgia, in the early 1920s. *Courtesy of the* American Bee Journal.

Dixie Beekeepers! Did you know that we have such a bee hive plant in your very midst where you can get what you need for your bees almost at your own gate and besides save the middleman's profit? Well, you have, and further the very best material for hive construction that will stand our rigid climate has been learned and is used exclusively which is our own soft, rich, southern, **Cypress** which does not decay, split or warp. Write at once for our **Cypress Bee Hive Catalogue** and remember that if it is anything you need or want for the bees we have it, at prices that will please you. We give prompt service and all orders carefully filled and appreciated.
Dixie Beekeeper is the only bee paper Dixie has and is a 32 page monthly publication. Subscription $1.00 a year. Sample copy free. It is devoted exclusively to the interest of beekeeping in our own land and to meet our own conditions and its contributors are our most progressive keekeepers. Subscribe today

J. J. WILDER, **Waycross, Ga.**

that in the southland, beekeeping was a profitable industry when properly handled and was an honorable occupation. He believed that the location for bees along the Flint and Apalachicola Rivers in Georgia and Florida could not produce a better flora than that of tupelo gum, gallberry and titi in April and May, creating one of the mildest light-colored honeys ever. Nesbit and other beekeepers moved their bees in December and January down by steamer to Florida, where they would leave them alone until they started foraging on maple in January and February. In managing swarming of his hives, he found it important to clip the queen's wings so she could not fly away and looked through the hives about every ten days. He stated that one hundred thirty-five-gallon barrels would be considered a good crop out of thirty hives, or one barrel to every three colonies. He also stated that after the harvest there are a surplus of bees that are consumers and not producers. He recommended that these bees could be taken out and sold to northern beekeepers who were not so fortunate to build up their colonies from the long, cold winter in time for the flow; by purchasing them from the South, they could get it to their crop in July or August. This added another profit to beekeepers. About three pounds of bees were taken from each hive, put into secure wire cages with enough food to get to their destination and received by their new owners in good condition, ready to help gather a new supply of honey in the northern season of July and August. Nesbit would ship to Ohio and Pennsylvania. He said it paid to have a young queen. So it was not an uncommon sight to see steamers out of Bainbridge loaded with thousands of colonies transporting up and down as the season came and went. The Maddox Commission Company handled numerous carloads and sometimes several thousand barrels of the product. Georgia and Florida at the time had a law forbidding transporting of bees or honey from an infected yard, as well as watchful inspectors to see that the law was carried out. By 1928, M.L. Nesbit was vice-president of the Tupelo Honey Exchange.

M.L. Nesbit's brother, Wilson Whitaker Nesbit, was also a beekeeper who had died three years prior to the article in 1921. In an eloquent obituary, the *Post-Searchlight* writes of him:

> *After an illness of several days, Wilson Whitaker Nesbit, passed away at the home of his brother, Mr. M.L. Nesbit, Saturday morning, Nov 2, 1918 on East Broughton St. He was 32 years old. He had only been ill a few days before dying of pneumonia; following an attack of Spanish influenza which he contracted in Thomasville more than two weeks ago. Born May 23 1886 he came to Bainbridge, GA in 1911. He was for many years connected to the*

GF & A shops where he held an important position, subsequently working for Miller Manufacturing in the same city. Then worked in the C.I. shops in Thomasville where he acquired many friends who will grieve to hear of his untimely death. He descended from that sturdy old scotch Presbyterian stock that suffered martyrdom and banishment at the hands of men rather than risk the displeasure of God. Capt. John Nesbit, an ancestor of the deceased an officer of the converters, was executed for loyalty to his religious principles in the year 1668 in the street of Edinburg, in the same year his sons came to America and settled in North Carolina. About a century later James Nesbit another ancestor located in Green County Georgia and his offspring contributed many illustrious pages to the historical achievement of both Georgia and Alabama. The deceased was son of Frank LeConte Nesbit and Elizabeth Lane Whitaker. His father still survives him. Wilson lived a life of usefulness and forgetfulness of self, and always thoughtful of others. The numerous floral offerings contributed by various friends and others, spoke most eloquently of the popularity and esteem in which he was held during his lifetime. Loved and respected by men of every walk of life and especially by those who held subordinate positions under him. Among floral offerings was one presented by the colored workman of the GF & A shops, who requested to his family that they could be permitted to pay this token of affection and esteem to their beloved superior officer. He was of a retiring disposition, modest in his demeanor and lived much because he loved much. He loved the beauty in nature, the birds in the trees and the flowers; he loved his fellows. One of his avocations was the culture of honey bees wherein he found a true delight, and as he passed away the postman delivered at his gate his magazine on bee culture which he always read with so much pleasure, and on the fronts piece there appeared a beautiful picture of the land of milk and honey.

He was laid to rest in Oak City Cemetery, and the newspaper wrote, "like unto Ben Adhem the following sums up his whole life; I pray thee, and then write me as one who loves his fellow men." The article referred to the original poem written by James Henry Leigh Hunt that goes like this:

Abou Ben Adhem (may his tribe increase!)
Awoke one night from a deep dream of peace,
And saw, within the moonlight in his room,
Making it rich, and like a lily in bloom,
An angel writing in a book of gold:—
Exceeding peace had made Ben Adhem bold,

A land flowing with milk and honey. This was the issue that the postman delivered to Wilson Whitaker Nesbit as he passed away in his brother's house on November 2, 1918. *From* Gleanings in Bee Culture.

And to the Presence in the room he said
"What writest thou?"—The vision raised its head,
And with a look made of all sweet accord,
Answered "The names of those who love the Lord."
"And is mine one?" said Abou. "Nay, not so,"
Replied the angel. Abou spoke more low,
But cheerly still, and said "I pray thee, then,
Write me as one that loves his fellow men."

The angel wrote, and vanished. The next night
It came again with a great wakening light,
And showed the names whom love of God had blessed,
And lo! Ben Adhem's name led all the rest.

The Apalachicola River section of the state is a beekeeper's paradise because it is one of the only places in the United States where it is possible to produce pure tupelo honey. Tupelo honey brings premium over all other honeys because of the fact that it might not granulate. But blending this honey with others will stop granulation, according to R.E. Foster, apiary inspector for the State Plant Board.

In April 1912, the same year and month that the *Titanic* sank to the bottom of the Atlantic floor, Wilder responded to a letter from W.H. Henderson from Greenville, Florida, sent to the *American Bee Journal* about the "Successful Bee-Businessman." Wilder wrote:

I believe anyone who has the ability and will take up and carefully carry out the methods of any successful beekeeper, will succeed at Bee-keeping. But, alas! Only every now and then one will do it. No wonder we have failures, and will have right on, so long as successful men's methods are ignored. But if they were studied and out in force, we would not lose another member from our ranks, and our industry would soon be what it ought to be, and should be.

When I have studied out another bee-keepers method that has been successful, it's all plain to me how he has succeeded: and when another man has carefully carried out my methods, I can't see how he can fail. He's bound to succeed. But only a few will do it and others never will, so there is no use to grieve when one, "faints by the way." Let's be encouraged so long as a few will follow us up in our methods, and continue to bring them plainly before others.

There's No Place Like Comb, as the Bee Said to the Honey

In 1981, Mamie Sorrell and Adeline Landrum had a vision to liven up their city of Hahira, Georgia, with a weekend arts and crafts fair. The event has since grown to welcoming 20,000 to 36,000 visitors to its town of 1,700 people for a weeklong honey bee extravaganza hosted by the festival members, known as the "Busy Bees." According to their website, the history of Hahira contributed much to the honey bee community, and the town was coined "Queen Bee Capital of the World."

This was because of the Puett Company, which established itself in 1920 and dealt with the raising of queen bees and the shipping of queens and package bees all over the United States and Canada. In 1953, a branch of Dadant & Sons beekeeping supply, which began in 1863, established a firm in Hahira, employing Garnett Puett Jr. as manager. Puett Company and Dadant & Sons was located in a two-story brick building that once occupied a cigarette manufacturing company in the 1920s. Garnett Puett died in 1971, and the Dadant & Sons shop has since moved to Umatilla, Florida.

The Commercial State of Bee-ing

In Wilder's book, *System of Beekeeping* (1927), he says that after his first good honey flow, he was ready to grow his business as fast as possible, so he hired on an overseer while he was out running the honey markets. As the business grew, his overseer could not keep up with the work, so he hit a turning point in the direction that he wanted his business to grow. He relaxed the idea of getting rich quick and halted for another plan. He called upon his hired help in the apiaries that he had scattered about and drew up a contract the following year to allow all his help an equal showing with him in expenses and returns. Eventually, Wilder took over the job as the overseer, instructing his method of beekeeping and having time to research honey markets.

His contract was a fifty-fifty split on wax and honey. The increase promoted the business to keep growing. The contract read:

> *The party of the first part agrees to furnish four hundred colonies of bees or more and all the necessary equipment for the same, including a honey house, workshop, containers, barrels can, pails, jars, etc. The party of the second part is to perform*

or furnish all labor necessary to carry on said business and properly care for the bees and their supplies from New Year's day to New Year's day. Also, to increase the number of colonies in each apiary or over the entire business not less than twenty per cent during the years. This included responsibility for all losses to the business caused by gross neglect such as forest fires or destruction of any colonies in any way. All comb destroyed by the bee moth or torn up in the honey extractor to be replaced by inserting of foundation in the frames at the total expense of the party of the second part. The party of the second part is also responsible to furnish his own home, truck and the maintenance. Second party also agrees to grade, pack, label and crate all honey ready for sale and ship to the first party half of the entire crop of beeswax and honey. Party of the second part also agrees not to have bees of his own or work with another party.

Wilder's method of beekeeping is essentially eight manipulation techniques that include when to start in spring. He recommends waiting for four to five warm days in a row and then proceeding in exact number of days of inspection and moving frames around.

Wilder claimed in his *System of Beekeeping* that he was the world's largest honey producer with fourteen thousand colonies in three hundred apiaries scattered over south Georgia and northern Florida. He says, "I love beekeeping as no man ever has or even can. It has been my life's long study and my sole occupation for the greater part of my life and when I pass out I want to leave something in the way a heritage of blessing to my fellow beekeepers that may live on after me."

Since 1886, queen bees have been shipped by mail, which on the whole was satisfactory, and losses were minimal. Roughly one million queen bees are sent by mail annually, according to Everett Oertel in the *History of Beekeeping in the United States*. He also explains that in 1977, selected queen bees were artificially inseminated to produce hybrid bees. These steps were the beginning in the commercial breeding of male and female lines.

By 1957, an estimated 1,200 commercial beekeepers operated 1,440,000 colonies in the United States. By the 1990s, the USDA reported 200,000 beekeepers as hobbyists and another 10,000 as "sideliners," or part-time beekeepers. Commercial producers—those owning 300 or more colonies—numbered about 2,000 and produced about 60 percent of the honey extracted annually in the United States.

Chapter 9

THE EQUIPMENT

He who tries to solve all the problems of beekeeping will find it takes a little longer than a lifetime. It may be viewed, first, as a science having for its object the attainment of the correct knowledge of all that pertains to the life, habits and instincts of the honey bee; and secondly, as a practical art, which regards all the attainments thus made and to be made, as the only reliable foundation of successful management.
—American Bee Journal *1 (1861)*

Early beekeepers kept bees in wooden boxes, pottery vessels or straw skeps. Around the middle of the 1800s, beekeepers were keeping bees in hollow logs called bee gums. These gums were tree trunks hollowed out by decay. Beekeepers increased their number of colonies each spring by capturing swarms and killed them in the fall by burning sulfur at the entrance of the hive so that the honey and beeswax could be removed; some of these bee gums could yield up to four hundred pounds of honey.

In 1849, *The American Bee Keepers Manual*, by T.B. Miner, was published as a practical treatise on the history and domestic economy of the honey bee, embracing a full illustration of the subject with the most approved methods of managing this insect through every branch of its culture, the result of many years' experience. The author wrote this book to bring attention to the neglect of management of the honey bee in the United States.

Over a fifteen-year span, four major inventions took beekeeping from a sideline interest to a full-on industry. The removable frame was the first of these inventions to spark the golden era of beekeeping.

Lorenzo Loraine Langstroth, a teacher and clergyman from Pennsylvania who had been interested in observing the habits of small bugs since he was a child, took up beekeeping as a distraction to his depression, an alternative to the anti-depressive drugs available today. At the age of forty-two in 1852, during his observation of bees, he discovered that bees would keep a bee-sized pathway—about six to eight millimeters wide—clear in the hive. So he decided to create a better way for a beekeeper to handle and manipulate the colonies. He wanted to help the colonies develop and grow and make it easier to collect honey without having to kill the entire colony at the end of the honey

L.L. Langstroth, inventor of the movable-frame hive, 1851. *From Dadant's* System of Beekeeping.

flow season. This small, elusive fact that beekeepers had not examined for the last few thousand years meant that Langstroth found the element needed to create a hive that was beneficial to both bees and beekeeper without having to destroy so much of the hive. He discovered that several open boxes that communicated with one another could be stacked and the queen could be confined to the bottom box using a queen extractor, due to her size, allowing the other bees to move upward to create comb honey.

Many other hive designs had come before Langstroth's, but he combined adaptations from other designs and, thus, created and patented the Langstroth hive. He asked a friend and fellow beekeeper, Henry Bourquin, who was a cabinetmaker in Philadelphia, to build his designed hive. He based the hive structure on the "bee-sized" pathway.

Langstroth did not earn any royalties from this patent because it was so easily infringed. Many entrepreneurial minds quickly copied his design and marketed them as their own. He didn't walk away a rich man, but he did get to receive notoriety from the Langstroth hive, which is still the common term used to refer to this style hive today. Langstroth was

appreciated by many as the father of modern beekeeping, and many knew he deserved more financial rewards for his discovery. In 1871, at the American Beekeepers Convention (of which Langstroth was currently president), a suspension to the order of business was called by Mr. King. He stated that a man by the name of Mr. Bickford had written in to the *American Beekeepers' Journal* suggesting that the beekeepers of America owed a lasting debt of gratitude to Langstroth and it would be proper for the journal to raise $5,000 for Langstroth as the inventor of the movable hive frame. A.I. Root, who contributed $50, also said that Langstroth's introduction of the movable frame hive had revolutionized bee culture and made rearing of Italian queens possible. Many had supported Langstroth, but Langstroth knew that if he wanted to fight in court against men for infringement on his design, the litigation would be exhausting.

The editor of *Gleanings in Bee Culture*, A.I. Root wrote a moral gem of an article in 1885:

> *I am very glad indeed to note the disposition of the bee-keepers of forbearing to copy the works of each other, patent or no patent. The Supply dealer who would unhesitately copy something well known to be the property of another, without getting the privilege of doing so, by purchase or otherwise, would very likely lose more than he made, so strong is the disposition of our people to give honor to whom is due.*

Economically, beekeepers that had large numbers of colonies were not interested in the shipping cost required to buy supplies, so many of them made their own equipment.

Langstroth and fellow beekeeper Samuel Wagner managed to transport Italian bees across the Atlantic in 1859 from Jan Dzeiron. The Italian bee was perfect to withstand cold temperatures and gentler tendencies than the German black bees. A year later, Langstroth wrote the book *The Hive and the Honey-Bee*, which provided the practical use and management of bees. This book is still in print today.

The creation of the Langstroth hive is often cited as the start of modern beekeeping and is still the preferred method of beekeepers throughout the world.

Foundation and Extraction

Next was the discovery of wax comb foundation. Johannes Mehring, a highly skilled German mechanic, was the man who invented the comb foundation maker. He created a machine that would manufacture embossed wax foundations in 1857. A.I. Root used a similar roller press in 1876. It subjected long sheets of beeswax to a pressure mold, which yielded hexagonal impressions. The old process was to peel off wax sheets that were dipped into wax on a board. The theory was that using the foundation sheets in the

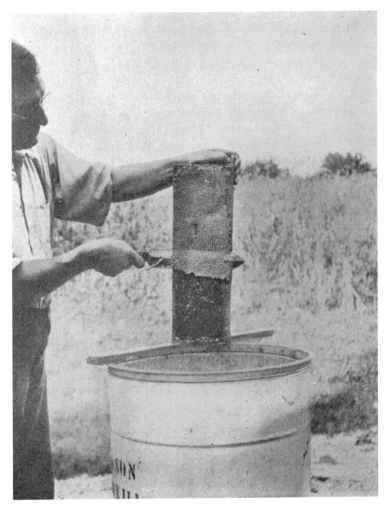

Uncapping honey. *Courtesy of the* American Bee Journal.

brood frames prevented the bees from building drone frames, which took up to one-fourth of the space available.

Shortly over a decade later, in 1865, the invention of the centrifugal honey extractor made large-scale honey production possible. By 1869, more than

One of the first honey extractors used in America. *Courtesy of the* American Bee Journal.

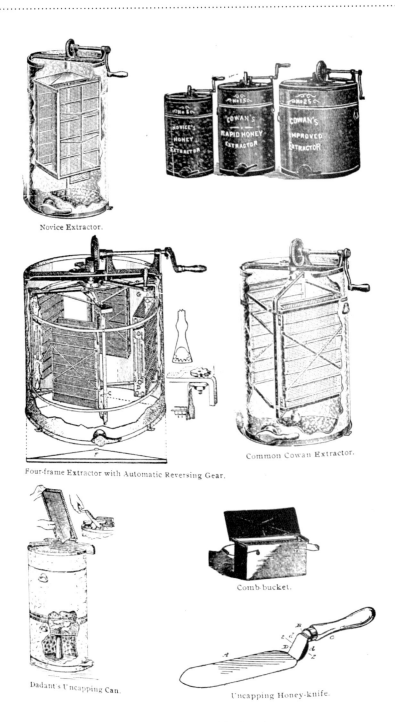

Novice Extractor.

Four-frame Extractor with Automatic Reversing Gear.

Common Cowan Extractor.

Dadant's Uncapping Can.

Comb-bucket.

Uncapping Honey-knife.

Honey extracting tools. *From Dadant's* System of Beekeeping.

sixty patents had been recorded on hives and appliances, which gives one an understanding of the public interest in beekeeping at the time. In an 1871 *American Bee Journal* article, Langstroth was asked to speak on the subject of Major Von Hruschka's mel-extractor. With this extractor, the frames were removed from the hive, the capping's were cut off with a honey knife and then the combs were placed into a wire basket inside the extractor. The handle on top of the extractor was turned rapidly to throw the honey out of the comb. Langstroth said in 1853, that he became interested in the subject of extracting honey from the comb and re-using the comb for the bees to easily refill. He had asked mechanics to help, but none of them had any bright ideas. If one of them had mentioned centrifugal force, he would have said, "Eureka!"

In the January 1903 issue of the *American Bee Keeper*, a monthly journal for the benefit of everyone interested in bees and honey, a Georgia man by the name of T.S. Hall wrote in with his concern over the benefit of using modern appliances, namely the honey extractor. In this letter to the editor, he tells the story of his conversation with another beekeeper:

> *Mr. Editor, I have read with much satisfaction what you and others have said on "Southern" honey. There should be more said and the subject sifted until our words mean what they say—until every honey eater, buyer and seller, will understand at a glance the difference between extracted and strained honey. There are several ways to get up strained honey; by dripping, by squeezing and by boiling, wherever you find the log and box-hive, you will find strained honey. With few exceptions, there is a certain time to "rob" bees by these primitive bee-keepers. Some "rob" on the old of the moon, some wait until corn "tassels out," and rob mostly "of a night." Their smokers consist of a roll of rags, with someone to do the blowing and ashes are blown into the honey. It is cut out to the cross sticks. Black comb, young bees and "bee bread" as they call it, all together and it is mashed up and allowed to drip, or it is squeezed out, or the whole is put into a pot and boiled and the wax bees and pollen skimmed off. An old gentleman said to me that he could not sell his honey at all. I asked him what shape it was in and he said it was strained and in a barrel. I asked him how he separated it from the comb or wax, and he said he "just put it all into a large pot and boiled it." Then he said, "dem bees done gone and just made a mess of dat honey." I took off the supers and the sections and to find some of the whitest honey I ever saw. It was gathered from that tupelo. He said,*

"dat honey not like my honey: my honey black and red. Dem bees do better in dem hives dan in mine." He had some strained honey that was very dark. We extracted some honey from an apiary at the same place and got some tupelo honey that had a fine body and almost water white. Many people have confounded extracted honey with strained honey, when there is a vast difference. The man that puts his money and labor into the business on the modern plan and produces an article of honey that is as far superior to strained honey is to black molasses. And then to have his honey classed with strained honey is not doing him justice. He should have the encouragement of all honey buyers and consumers. This strained honey is not confined to any certain locality or section of the country; but it will be found south, north, east and west—wherever the hollow-log and box hive is kept. Yours truly, T.S. Hall.

The Smoker

Another nearly equally important beekeeper who collaborated with Langstroth on many projects was Moses Quinby. From the 1600s to the 1800s, honey was assumed to be a local trade from framers and villagers

Lighting the smoker. *Photo by Chrys Rynearson.*

A close-up of getting the smoker going. *Photo by Chrys Rynearson.*

who kept bees to supply themselves and locals with honey. According to Pellet in 1938, Quinby was the first commercial beekeeper in the United States whose sole livelihood relied on the production of honey. He was a successful commercial beekeeper who made changes to the smoker two

years before he died in 1873 by adding bellows to the firebox. His model increased the airflow in the firebox and made it easier to hold and control the amount of smoke a beekeeper needed. He also wrote an important book, *The Mysteries of Beekeeping Explained* (1853). Quinby died before he could perfect his invention, but T.F. Bingham came along and improved the original draft. Quinby also produced section honey in the 1830s and 1840s and did not claim that the method originated with him.

The Veil

The earnest desire of succeeding is almost always a prognostic of success.
—James Heddon, 1885

In the book *Success in Bee-Culture* by James Heddon (1885), he states that where bees are well bred and properly handled, little or no protection from stings is needed. In his own apiaries, he used little or no protection. But where bees are belligerent and manifest an especial proficiency in the use of their javelins, a face protector is a great comfort and convenience. Heddon went on to say that the only color the veil should be is black because all other shades are more or less difficult to see through. Nowadays, veils are generally only white.

A beekeeper with veil in the early 1900s. *Courtesy of Gleanings in Bee Culture.*

Magazines and Publications

Periodical publications and national organizations related to beekeeping started around the mid-1800s. The *American Bee Journal* was first published in 1861 by editor Samuel Wagner. In 1851, Wagner was introduced to Langstroth by Reverend Joseph Federick Berg, a pastor in Philadelphia. Wagner encouraged Langstroth to write a book based on his moveable hive system, which he later did. In 1853, he wrote *The Hive and the Honey-Bee*, in which he made the prediction that a bee journal needed to be published in America. So in 1861, the first issue appeared of the *American Bee Journal*, with Langstroth and Moses Quinby as contributors as well as advisors to the paper.

The *Journal* suspended its activities on account of the Civil War and released volume two in 1866. Three years prior to the journal being back on the press, in April 1863, at age forty-six and impoverished, Charles Dadant immigrated to the United States with his wife and children. They settled on a small brush farm two miles north of Hamilton, Illinois. Dadant intended to make a living by growing grapes, the principal crop of his native Burgundy and Champagne, France, but in Illinois, their cultivation proved insufficient. The following year, he obtained two colonies of common black bees in box hives, the modest beginning of what soon would become a prominent career. Arriving with no knowledge of English, he taught himself to read it well, but he never was able to speak it fluently.

During the next thirty years, Dadant contributed hundreds of articles to European and American bee journals, in particular the *American Bee Journal*. To the American bee men, who for the most part were receptive to the movable-frame hive, he advocated from 1870 on the use of large hives. From 1885 on, he disagreed with the contraction principle and small hive advocated by the Michigan beekeepers James Heddon and W.Z. Hutchinson. To European bee men who still used fixed comb hives (also referred to as the fixistes), he urged from 1869 on the use of movable-frame hives; he was an important partisan of the mobilistes. The first and principal advocate of the movable-frame hive to Frenchmen, he was largely responsible for its adoption by the French and other Europeans; it is by his name that this kind of hive is known on that continent. (In the twentieth century, Europeans have preferred the deeper dimensions of the Dadant hive and Americans the shallower dimensions of the Langstroth hive.) From 1881 until 1888, Dadant and his son Camille Pierre corresponded with Langstroth concerning a fourth edition of Langstroth's *The Hive and*

the Honey-Bee, the classic work on the physiology and habits of the honey bee and the principles of its culture. Langstroth, at times incapacitated by melancholy, entrusted the revision of the book to the Dadants in 1885, and they published it in 1888. The French translation by Charles Dadant was published in 1891. Camille Pierre Dadant assisted his father in several revisions of *The Hive and the Honey-Bee* (1888, 1893, 1896 and 1899). The four succeeding editions (1907, 1922, 1923 and 1927) were Camille Pierre's work. He authored *First Lessons in Bee-Keeping* (1915), *The Dadant System of Bee-Keeping* (1920) and *Bee Primer* (1921). Camille Pierre was president of the National Beekeepers' Association in 1906–07. In 1912, Dadant & Sons acquired the *American Bee Journal*; Camille Pierre was its editor and publisher from that year until 1925. His sons, Henry Camille and Maurice George, later became active contributors to the journal. Dadant, along with L.L. Langstroth and Moses Quinby, contributed to the early development of the honey extractor, which was responsible for the replacement of the then popular comb honey with liquid honey commercially. Charles and his son Camille published the pamphlet *Extracted Honey* in 1881. In 1878, they began to manufacture comb foundations, which was a new field and in a crude state of development. Charles also began to appeal for laws prohibiting the adulteration of honey and the sale of glass jars of glucose under the name of honey in the same year.

C.P. Dadant died in 1938. G.H. Cale Sr. took over as editor of the *American Bee Journal*, and Joe Graham has carried out this position since the early '70s.

The *North American Bee Journal*, devoted to bee culture, was started in August 1872, and *Gleanings in Bee Culture* started in 1873.

A year after the end of the First World War, another publication for beekeepers was born in Georgia. The *Dixie Beekeeper*, created by the successful J.J. Wilder in 1919, cost one dollar a year. Wilder also had a column in the *American Bee Journal* with the same title, which he used for readers to write in with questions that he would answer. Wilder, being a successful beekeeper, noted on the first page of the first issue of the *Dixie Beekeeper*, "For years we have this in our minds and hearts with a burning desire to see it started, not for the publicity, no, a thousand times no but because we love our interesting industry."

NORTH CAROLINA

In 1976, the honey bee became the state insect of North Carolina. Flowering plants in the state include blackberry, gallberry, goldenrod, holly and ironwood. In the mountainous area is found the esteemed sourwood. Honey from this source usually passes directly from producer to consumer at far above the price of other honeys. Also found are sweet bay and tulip poplar.

The sourwood tree, found in the Appalachian Mountains from northern Georgia to southern Pennsylvania, is, in spite of its name, spicy and sweet. It is used for cooking in glazes and has a nice lingering aftertaste. Sourwood is the prevailing source of quality honey.

North Carolina was named by the *American Bee Journal* in 1918 as fast becoming "progressive" in beekeeping ranks. North Carolina ranked among the first states in number of bees. And up to the last year or two before 1918, very few of the bees were in anything but box hives.

In North Carolina—one of seventeen states where the honey bee is the official state insect—honey bees pollinate strawberries, blueberries, blackberries, cucumbers, melons, peaches, pumpkins, squash, apples, watermelons, cotton, peanuts and soybeans.

In 1731, naturalist John Brickell, a resident of Edenton, North Carolina, observed, "The Bees are in great plenty, not only in hives but are likewise to be met with in several parts of the Woods in hollow Trees, wherein are frequently found vast quantities of Honey, and Wax." In 1751, Swedish traveler Peter Kalm, noting the practice of beekeeping among two North Carolina farmers, concluded that "bees succeed very well here."

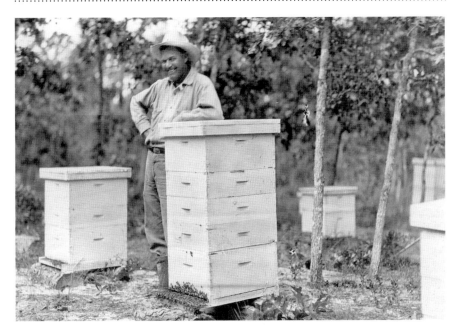

J.E. Dodson Apiary. The following is transcribed from the back of this photo: "'Sweet Potato' Dodson also likes sweet honey. He was smiling a very happy smile when on May 19th he found all his hives filled with beautiful white honey. Mr. Dodson is a good beekeeper and has done a great deal to encourage modern methods of beekeeping in Brunswick County. Through his influence and efforts a great many farmers in his county have changed from box hives and round gums to modern hives and are delighted with the change. So far as his own bees are concerned, Mrs. Dodson is the real man behind the gun. She is largely responsible for building up and maintaining the beautiful apiary at their home. She is the real keeper of the bees at the Dodson apiary." *Courtesy of Special Collections Research Center, North Carolina State University Libraries, Raleigh, North Carolina, ua023_007-001-bx0002-002-003.*

The State Beekeepers Association was organized on January 11, 1917, and its publication was sent free to its members and interested beekeepers. In the ten years prior to 1917, there had been some desire and interest from beekeepers to form a state beekeeping organization. However, since there was no official employee in beekeeping work in the state and no beekeeping public projects, it was difficult to begin the organizational work. In 1915, the United States Department of Agriculture and the Bureau of Entomology assigned an expert apiculturist, Dr. George H. Rea, to the state temporarily to survey the conditions of beekeeping in the state. His work was so well accomplished that the USDA and the State Extension Service agreed to employ an extension specialist permanently in North Carolina, with headquarters in the Division of Entomology, State Department of Agriculture, in Raleigh. His work began in 1916, and plans were made to

The North Carolina Beekeepers Association met in Winston-Salem on September 10, 1924. *Courtesy of the North Carolina Beekeepers Association.*

hold a state beekeepers' meeting at the Board of Trade Hall in Winston-Salem, North Carolina, on January 11, 1917. Nearly 700 beekeepers were invited. Most notable were A.I. Root of Medina, Ohio, and Dr. E.F. Phillips, both of whom arrived late by train and brought their own papers to present. The meeting was a huge success. Phillips spoke about swarm control, and Root spoke about bees in pound packages and wintering. In attendance were nearly 150 beekeepers from twenty or more counties. By the evening's end, the state association had signed on nearly 40 members who paid their yearly dues of one dollar. By December of that same year, enrollment had grown to 131. Dr. Phillips was quoted that evening as saying, "No state has held ten meetings to equal this, and there is no state whose first meeting equaled this."

As of 2012–13, the majority of beekeepers in North Carolina are considered backyard beekeepers, whereas the vast majority of the honey bee colonies (88.2 percent) are managed by commercial beekeepers.

> *Way back in the year of seventy-five I had lots and lots of bees,*
> *In nail kegs, boxes and flour barrels and cut off hollow trees.*
> *And Along in June the 1ˢᵗ full moon, I would take off the tops of the hives,*
> *and cut out the honey till I felt right funny, way back in the seventy-fives.*
> *But here of late, all the honey I've ate is stuff I've bought at the store,*
> *But it don't taste right when I take a bite and blamed if I want anymore.*
> *Things ain't the same in this honey game like when I kept my bees in trees.*

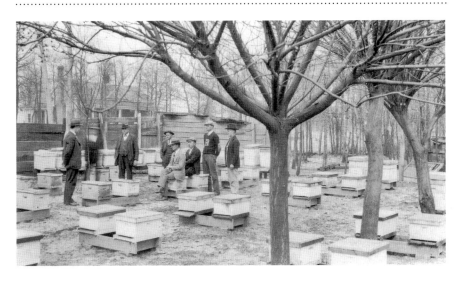

Men in an apiary. *Courtesy of Special Collections Research Center, North Carolina State University Libraries, Raleigh, North Carolina, ua023_007-001-bx0002-002-015.*

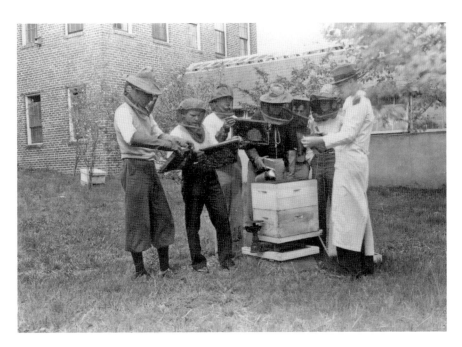

Beekeepers behind the zoology building at the University of North Carolina in Raleigh. *Courtesy of Special Collections Research Center, North Carolina State University Libraries, Raleigh, North Carolina, ua023_007-001-bx0002-003-007.*

For here of late some kind of fate makes the worm eat up my bees.
But I got a friend at West End, who has tons of honey to sell,
But this honey's not good, it do for food And he feeds on molasses as well.
Of course he denied it, and won't advertise it, but I know from experience,
Be Gad,
For pounds twenty-five, for each box and each hive is all there is to be had.
He has boxes and frames, of different names, and some kind of three
banded bees,
He takes bee papers, cuts all kinds of capers and he reads everything he sees.
He acts like he's crazy, he's not a bit lazy and he has always got honey to sell,
But if I can't keep bees in boxes and trees, Why the durned business can
go to H---.
—*Luther A. Fink, Cameron, North Carolina,* Dixie Beekeeper, *1922*

In an article written in 2006, Daniel J. Salemson states that the future of beekeeping has grown less secure as it entered its fourth century in the state. In the early 1990s, beekeepers in several western counties had reported a sharp loss of bees from tracheal and varroa mites. Bees that drift from one colony to another spread the mites and soon infested other colonies across the state, leaving devastating results. According to federal census data, North Carolina beekeepers experienced a drop of almost 50 percent in the number of recorded hives and in honey production between 1987 and 1992.

Nearly $1 Billion Paid for a Bearded Beekeeper's Business

Burt Shavitz, the famous bearded man on the yellow, red and white chapstick labels for the company known as Burt's Bees, has a very interesting story—I'd say the most interesting of any beekeeper turned hive product–inspired conglomerate. Burt originated in Maine as a beekeeper selling honey out of the back of his truck off the side of the road before he partnered up with Roxanne Quimby making candles in 1984. They grew from their initial $200 made at a local craft fair to sales nearing $20,000 by the end of their first year. Their first place of production was in an abandoned schoolhouse that they rented from a friend for $150 a year. In 1989, Zona, a New York boutique, ordered hundreds of their candles, and that led to Burt's Bees adding more

employees. Roxanne began to incorporate more homemade personal care items into the Burt's Bees production line. By 1991, when the company became incorporated, it had a variety of bee-inspired products. The famous chapstick became its bestseller.

In 1993, the production company moved from Maine to North Carolina. At the same time, Burt was supposedly forced out of the company. In 1994, the eighteen-thousand-square-foot building opened in Creedmoor, North Carolina. Chapel Hill was the site of the company's first retail store. By 1998, Burt's Bees products were in four thousand locations, with sales exceeding $8 million. In 2007, the Clorox Company reportedly paid $925 million to acquire Burt's Bees.

Chapter 11

GOVERNMENT SUPPORT

Volume 28 of the *Beekeepers' Review* explains that the Smith-Lever Agriculture Extension Act of May 8, 1914, provided a permanent national system of agriculture work to be carried on with federal and state funds through the state agriculture colleges, in cooperation with the United States Department of Agriculture, by means of instruction and practical demonstration in agriculture and home economics to persons not attending the colleges. The act was introduced by Senator Hoke Smith of Georgia and Representative A.F. Lever of South Carolina to expand the vocational, agricultural and home demonstration programs in rural America.

The Smith-Lever Act appropriated money as follows: $10,000 of federal funds annually to each of the (then) forty-eight states. In addition to this $480,000, the act appropriated for 1915–16 $600,000 of federal Smith-Lever funds. This sum would be increased annually by $500,000 until 1923, when annual government appropriation was set at $4,580,000. The additional appropriation was divided among the states in the proportion of the states. Any state, however, to share in this extra federal fund had to appropriate within the state. The money from the state brought the joint demonstration fund to $1,680,000 in 1915–16.

In addition to the fund, however, the USDA during 1916 would expend its own appropriations for farmers' cooperative demonstration work and for other direct field instruction in special subjects over $1,025,000. States raised sources within the state and spent demonstration work at a total of $2,650,000. This made a grand total of $4,750,000 to be spent in the fiscal

year 1915–16 in bringing practical and helpful instruction to the farmer and his family in their own communities.

The *Beekeepers' Review* was happy to announce this act, as it was glad to see a possibility of the honey producers being benefited. An article noted:

> *Never in the history of our country was there a gigantic amount of money available for promotion work among the agriculturalist as this. The national and state beekeepers association should see to it that we, as honey producers get our share of the Smith Lever appropriation spent in representing our pursuit. One or more able men well versed in brood diseases, as well as general beekeeping should be paid from this fund in each state. Every state secretary should make it a point to immediately get in touch with the proper officials, which is understood to be your State Agriculture College. Our national secretary should take in hand states where no association is formed and that said state is properly represented by a demonstrator. Then there may be states where for some reason the states secretary does not act. On such case the National secretary should act instead. Now is the time to get busy!*

Since 1950, the federal government has helped support honey production after honey prices dropped following the end of the Second World War because of excessive inventory and reduced demand after sugar rationing. Congress reacted by introducing a price support program for honey in the Agricultural Act of 1949. Beekeepers and honey packers were having difficulty covering costs, and bee colonies began to decline, so the legislature was to ensure that there would be enough honey bees for pollination. The honey and beeswax sales exceeded the revenue from pollination, and Congress subsidized honey production at prices that would allow beekeepers to maintain their operations. The honey program allows beekeepers to obtain a federal loan using the honey they produce as collateral. Borrowers can repay the loan and redeem their collateral at either the support price or at a loan repayment rate. The Omnibus Budget Reconciliation Act of 1993 reduced federal subsidies for honey by reducing the support price and by tightening the limit on the payments that any one producer could receive.

With a contribution of more than $65 billion annually to Georgia's $786.5 billion economy, agriculture is the main driver of the state's economic engine. Agriculture is also a primary source of employment for Georgians, with one in seven in the state working in agriculture, forestry or related fields. In 2007, there were 47,846 farms in Georgia encompassing 10,150,539 acres of land with an average size of 212 acres per farm.

From the north Georgia mountains through the rolling Piedmont to the sandy coastal plains and the coastal marshes, the state's geography and climate provide perfect conditions for a variety of agricultural pursuits. Georgia farmers produce more peanuts, pecans and watermelon than any other state. Georgia also leads the nation in broilers and value of egg production. Vidalia onions, grown only in Georgia, are recognized and appreciated as some of the sweetest, best-tasting onions in the world.

The 2008 Farm Bill authorizes funding for research on CCD and other issues. It also stipulates that the honey's country of origin be indicated, enabling consumers to distinguish U.S. honey from imported honey. Other provisions in the Farm Bill support honey producers through the bill's crop insurance and permanent disaster assistance programs. Since enactment of the 2008 Farm Bill, the USDA has created the Emergency Assistance for Livestock, Honeybees and Farm-Raised Fish Program (ELAP). This program, administered by USDA's Farm Service Agency, provides disaster assistance for honey producers.

Chapter 12

SOUTH CAROLINA

Beekeepers walk to the beat of their own drum.
—Scott Biering

According to data on southern beekeeping from the U.S. Census Bureau of crop estimates, the number of colonies on farms in South Carolina on April 15, 1910, was 75,422, compared to 189,178 in North Carolina and 130,549 in Georgia. In 2012, the USDA census reported that the number of colonies recorded in South Carolina was 10,083, with 461,123 pounds of honey collected. Georgia had a cool 2,999,818 pounds flowing in from 64,213 colonies. Some of South Carolina's flowering plants are alder, clover, gallberry, gum (black and tupelo), persimmon, privet, tulip poplar, sourwood and vetch.

Just over fifty miles northwest of downtown Charleston is a city like no other called Bee City. Yes, you heard me right, a real bee city. Well, it is a smaller version of a city, but nonetheless, it has streets and signs and even the first bee church. Archie Biering and his wife, Diane, had a shop in the early '90s in Cottageville where he welded and stored tractors, and he decided to build a small city just for bees. It has grown into a petting zoo with lemurs and an offsite apiary of 130 and is now owned by their son Scott. They have built their reputation through local sellers and state fairs since they set up their first hive boxes in 1989. In 1993, an article was written about Bee City, and a schoolteacher thought it would be interesting to bring her students there, as they were learning about pollination. Other schools became interested

in making the local buzz town into a field trip adventure. In keeping up with the demand, zoo animals became part of the scenario. With some of the hives bordering swampland on the Edisto River, the Bierings are able to harvest sought-after tupelo honey of the black gum tupelo in late spring.

In the '80s, Scott Biering wasn't too impressed with the idea of being a beekeeper like his father and grandfather had been. He was destined for other things in life—or so he thought. He joined the army and then later worked for UPS. His dad asked him one day if he wouldn't mind helping a friend of his move a swarm out of their house. Reluctantly, but with strong love for his father, he agreed to help remove the hive. The owners were kind and gave him money for the job. "Hmm, I got paid for this?" he thought. Two to three years later, after self-trials on how to and how not to remove bees' nests, Scott took out an ad in the Yellow Pages for a swarm removal service. The rest was history, according to him.

Larry Haigh got his start in keeping bees during a visit to Alaska. He never thought he'd come back from Alaska keeping bees, but he did. He and his wife, Debbie Fisher, along with a few other neighbors, formed the Charleston Area Beekeepers Association (CABA) in 2010. Once consisting of a handful of members, it has now grown to over one hundred. Their mission is to promote, educate and support responsible beekeeping practices that benefit honey bees, all aspects of beekeepers, the citizens of our community and the environment of coastal South Carolina. Debbie now heads up the Honey and Bee Expo in Charleston, which had its first successful opening in the spring of 2013. Vendors from all over the Low country joined together to promote keeping bees with top bar hive demonstration, honey cotton candy, education of pollination and live beehive observations—and don't forget the sale of local honey. It even offered a screening of recent honey bee documentaries.

Small-time South Carolina beekeepers got a sweet bill passed into law that exempted them from certain regulations imposed on larger sellers in 2012. Before the change, even families wishing to sell honey at a farmers' market were required to harvest and strain it inside a specially designed "honey house." Larry Haigh had already built one of his own for himself in his backyard, including painting the walls in food-grade paint, installing three separate sinks for washing hands, cleaning off utensils and scrubbing the floor. The bill states that beekeepers who produce no more than four hundred gallons (4,800 pounds) of honey annually and who only sell directly to the end consumer are exempt from inspections and regulations requiring honey to be processed, extracted and packaged

Larry Haigh in front of his honey house. *Photo by Caleb Quire.*

Fresh shavings of beeswax. *Photo by Caleb Quire.*

in an inspected food processing establishment, or from being required to obtain a registration verification certificate (RVC) from the Department of Agriculture. However, labels are required on all containers of honey sold in South Carolina. Beekeepers must file for the exemption on forms to be provided by the Department of Agriculture.

Devorah Slick's first memory—or, as she would say, her intense infatuation with bees—dates back to when she was very young. She doesn't know exactly when or how it came about. "I had no one around me that was an influence with bees. It just came very instinctively," she says. "I learned many years ago that my name, *Devorah*, means 'bee' in Hebrew. This set off an internal illumination that is very hard to translate into words. It was as if there is some mystery or destiny I was born with to be connected to bees. So all my life, way before I had the great opportunity of actually beekeeping, everyone around me knew that bees were my thing!" Her grandchildren call her "Granny Bee" or "G-Bee" for short. Several years ago, she was reading the *Moultrie News*, which featured a story about CABA. From then on, she attended every meeting for several years. Devorah says that early on, she felt she had a natural intuition about the care of bees and studied intently from those who followed the path of the biodynamic realm of beekeeping, from Rudolf Steiner (circa 1923) to the modern-day guru Gunther Hauk of Spikenard Farms at the bee sanctuary. Michael Bush, a beekeeper from the '70s who also believes in no treatments or chemicals, has played a major part in shaping her beliefs about what's best for her bees. "I enjoy harvesting honey; it is a great pleasure indeed. However, I am a real stickler for never taking the bees' stash! I leave ample amount for the bees first and foremost." She states that it's not all about the honey for her. It's their nutriment, and she feels very strongly about that. She does not feed her bees sugar either. "I use 'their honey' along with an organic dried flower mix made into tea and, depending on the time of year, a little HoneyBHealthy [essential oils] mixed in. I make my own now of that."

"My hives have never, from day one, been treated whatsoever. No chemical has ever been in my hives. Another thing I am extremely adamant about, I do use a bottom oil trap for SHB [small hive beetles]. This non-invasion method has been extremely effective for doing away with any SHB that might try to invade. The bees run the SHB to the bottom, where they fall into this oil, and *boom!*" she states.

Her belief is strong that if chemicals, sugar and the like are kept out of the hives, the bees have a chance to become strong. Once the hives are strong, they can manage their own issues, according to Slick. She states that the key

is to do all you can as a beekeeper/guardian to enable the bees to become strong, and they will do the rest. "After all, bees have done this for eons upon eons. It was only when man became so overly involved trying to take over the hive that the bees declined. I am in the highest hopes and belief that if we would change some of these practices and allow the bees to build up their colony strength, the bees will survive and thrive beautifully!"

> *Bees live as people should live: naturally, symbiotically, and in a manner that only contributes positively to the world around them.*
> —*Ted Dennard*

Ted Dennard, a beekeeper from Georgia, is doing more than selling boutique honey from his classy gift shop, Savannah Bee Company, in Savannah, Charleston and numerous other retail outlets across the globe. Ted is also founder of the Bee Cause Project. He and the company's executive director, Tami Enright, are supporting the future of honey bees by inspiring thousands of young schoolchildren to learn about bees through observation hives installed in their schools. The school that receives a honey bee observation hive agrees to pay it forward by running an annual fundraiser to help pay for the next bee family that it adopts. Through this program, honey donated from Savannah Bee and 100 percent of its profits are used to support the Bee Cause Mission, which seeks to "stimulate curiosity in young people about the importance of honey bees in our lives and the need to understand and embrace them and to care about their well-being through the installation of bee hives in 1,000 schools." The honey for this fundraiser is from gallberry, white holly, saw tooth palmetto or tulip poplar.

Beekeepers interested in expanding their craft into queen breeding did so best in the South. According to Kenneth Hawkins in *Beekeeping in the South: A Handbook on Seasons*, written in 1920, it was the advice of Ben G. Davis, H.D. Murray and several other southern queen breeders that it would be advisable for a beekeeper to locate south of Charleston, South Carolina, if he wished to produce pound packages of bees. The wintering of bees was based on having warmer weather early in spring. For any potential beekeeper, researching the area was important to their success.

The South Carolina Beekeepers Association established its master beekeeping program in 1996. It was designed to provide students interested in becoming successful beekeepers with the basic knowledge and skills needed to keep bees and to be able to share their knowledge enthusiasm and with the public: "We define a successful beekeeper as one who can keep their

bees alive for at least one year and though this is not an impossible task, we have found that beekeepers that participate and complete training programs have a better chance of being successful beekeepers."

The program offers four levels to the beekeeper. The first is a certified level that shows the student how to properly light and use a smoker and recognize various stages of brood and caste of bees. The student will be able to find the queen; differentiate between brood, pollen, capped and uncapped honey; and describe the functions of the hive. The student in the certified level must pass a written test. The second level is the journeyman, which also has a test and includes knowing how to score a jar of honey like a judge would and identifying anatomical structures of the honey bee, several odors related to beekeeping and the parts of a flower. Lastly, the journeyman must complete public service work in beekeeping that could include presentations to programs about beekeeping or serving as an officer for a local beekeeping organization. The third level of organization is the master beekeeper, which can also function as a sideliner or commercial beekeeper. This level of the program includes many areas of beekeeping such as honey and bee-related judging, bee behavior, biology and business aspects. This level includes having at least three years' experience as a journeyman, continued public service work and expertise in extraction of honey. The master beekeeper must demonstrate expertise in production of cut-comb honey by winning first or second place in an authorized honey competition and expertise in the production of crystalized honey by also winning first or second place in state fairs or competitions at state, regional or national beekeeping meetings. These are only a few of the requirements needed to obtain this level. Lastly, the master craftsman beekeeper must pass an oral test, demonstrate practical experience in a minimum of seven required areas, have at least two years' experience at the master beekeeper level, complete fifteen units of public service work in beekeeping, present a program at a South Carolina State Beekeepers Association annual conference and participate in a university-sponsored research project.

Charlotte Anderson, a master beekeeper, owns Carolina Honeybees Farm in Pickens, South Carolina. She started selling excess honey from her beekeeping hobby before it became her passion and a business, according to an article written about her on the website for Certified South Carolina Grown. The article states that she has been collecting honey from her bees for the past several years, concentrating her sales in the Upstate. She markets bottles and jars of raw unfiltered honey, but her specialty is

creamed honey. In addition to honey, Charlotte produces beeswax candles made in the state totally by South Carolina workers—honey bee workers, that is. The bees work hard to produce beeswax. It is said that the bees need to eat seven or eight pounds of honey in order to produce one pound of wax. The article goes on to an interview with Charlotte in which she states that she is building her customer base through word of mouth and repeat shoppers. She currently manages twelve hives and would soon like to expand to twenty hives. Now, that's a lot of honey to spread around! "My best venues are festivals and farmers' markets," she said. "Over time, I could see a larger percentage of my sales generated off the farm."

Dr. Mike Hood, professor of entomology and honey bee expert at Clemson University, says 95 percent of the beekeepers in South Carolina are hobbyists who sell their local honey from their homes, at farmers' markets or in retail stores. But the sweetest value of honey bees is that honey production equals about $1.2 million per year.

The 2013 Beekeeper of the Year honor was awarded to master beekeeper Sally Adams in a ceremony at Clemson University. She is only the third woman in the state to receive this award. Her once single hive has grown into eighty. She has taken her beekeeping from a hobby to a business and is now the owner of Mama Beehive Honey Farm in Clover, South Carolina. In an article written about her in *Lake Wylie Magazine* in the spring of 2014, she states that all of her products are 100 percent natural and that she uses a holistic approach to her beekeeping. "Healthy bees makes healthy honey," she has said. She keeps some of her bees on farms to pollinate crops and on a large apiary on a piece of land off Lake Wylie Road. She sells her products in various local retail stores and restaurants and every Thursday during the Old Market season in downtown Rock Hill. Twenty years ago, she was looking for a way to ensure she had fresh, pure honey for her tea, so she went on the hunt for quality honey. Adams, who had been living in Virgina, learned beekeeping from an old-timer in Virginia, she has stated. "Not many dedicate their time to educate young people about the industry and importance of honey bees," she has said.

But that is exactly what Adams and Anita Lehew, a fellow journeyman beekeeper and friend, do. They present a lively education program that teaches honey bee culture to children. Lehew and Adams are known around York County as the "bee ladies" and have taught nearly twelve thousand school-aged children about their trade and honey bees over the past three and a half years. Lehew has since retired from the Bee Ladies, and Melanie

Fleming, a South Carolina certified beekeeper, is now on board. Fleming is passionate about both children and honey bees. Their "Be the Bee" program meets the North Carolina/South Carolina state science academic standards. Adams says it's fun for the students and for her and Fleming.

Chapter 13

MEAD

Made of honey, water and yeast, mead is a fermented beverage that dates back thousands of years. The result is a wine-like intoxicating drink that converts the glucose and fructose in honey into alcohol. Mead existed long before people even knew what yeast was. Many monasteries had their own beehives for the production of beeswax, so they also had a surplus of honey to make a concoction that was, well, quite heavenly. Mead comes in a variety of styles depending on its base ingredients beyond just honey, water and yeast. The term "medicine" is rooted in metheglin, which is traditional mead with added herbs and/or spices such as cinnamon, ginger, coriander and nutmeg. A braggot includes malted barley and hops, which gives the mead characteristics of a beer. Cyser is a type of mead made by mixing apple juice with honey during fermentation. A melomel-style mead is made by mixing honey and fruit during fermentation or adding fruit to the mead after fermentation. Since meads pair well with spicy foods, another style is the capsicumel, which is flavored with chile peppers and may be mild or hot.

THE HONEYMOON

Legend has it that Cupid would dip his love arrows in honey before aiming them at unsuspecting lovers.

Within many cultures in Europe, including Welsh, German and Scandinavian, mead was often consumed during a wedding celebration as a toast to the bride and groom. After the wedding, the couple was given enough mead to continue the toasting for one month following the ceremony, or one cycle of the moon—hence the term "honeymoon."

Not only was mead great for toasting and celebrating, but it was also considered an aphrodisiac and was said to increase fertility and virility. What more do you need on a honeymoon? It was believed that by drinking mead for that first month, the bride would become fruitful, and a child would be born within the year. Often, the groom, filled with his fair share of mead, was carried to the bedside of his bride. If, nine months later, a baby was born, credit was given to the mead!

Got Mead?

Mead was easier to make than beer but was more expensive if you did not have your own supply of honey. It was produced by boiling large quantities of honey with spring water, occasionally adding flavor ingredients like spices and herbs and then leaving it in a barrel to ferment for six months or more. A colonial-era history of the Carolinas, written by historian John Oldmixon, notes that the bees swarmed there six or seven times a year, and the metheglin made there was a Malaga sack, which refers to being a sweet white wine.

Mead is not a complicated thing to make, but it can be a hard thing to make well. This was a basic recipe from a 1699 cookbook by Sir Kenelm Digby called *The Closet of Sir Kenelm Digby Knight Opened*:

Take one measure of Honey, and three measures of water, and let boil till one measure be boiled away, so that there be left three measures in all: as for Example, take to one pot of honey, three pots of water and let boil so long, till it all comes to three pots. During which time you must skim it very well as soon as any scum riseth: which you are to continue till rise no scum more. You may, if you please, put to it some spice, to wit, cloves and ginger: the quantity of which is to be proportioned according as you will have your Meathe, strong or weak. There are some that put either yeast of beer, or Leaven of bread into it, to make it work. But this is not necessary at all: and much less to set it to the sun. Afterwards to Tun it you must let it grow Luke-warm, for to advance it. And if you do intend to keep your meathe

a long time, you may put into it some hops on this fashion. Take to every barrel of meathe a pound of hops without leaves that is, of ordinary hops used for beer, but well cleansed, taking only the flowers, without green leaves or stalks. Boil this pound of hops in the pot an half of fair water, till it come to one pot, and this pot is sufficient for a barrel of meathe. After six months you draw off the clear into another barrel, or strong bottles, leaving the dregs, and filling up your new barrel, or bottles, and stopping it or them very close. The meathe that is made this way in the spring in the month of April or May which is the proper time for making it will keep many a year.

In the *Beekeeping for Beginners* book by J.P.H. Brown published in 1898, the recipe for mead is mentioned under the medicinal preparation of honey. Brown calls for twelve gallons of water and the whites of six eggs, which should be mixed well. Then add twenty pounds of honey, boil one hour and then add cinnamon, ginger, cloves, mace, rosemary and one spoonful of yeast in a barrel, keeping the vessel full as it works. After working, stop close and bottle for use.

An article published on Thrillist.com in June 2014 states, "According to a study by the American Mead Maker Association, mead's producer community has exploded 130% since 2011, making it the fastest growing alcoholic beverage category in the US." Meads have come a long way in terms of how they are produced in the last few years. The understanding of the addition of yeast nutrients and aeration during primary fermentation has sped up the process to create finished, drinkable mead by way of supporting the yeast cells while they convert sugars into alcohol

The tasting room at Starrlight Meadery in Pittsboro, North Carolina. *Photo from the author's collection.*

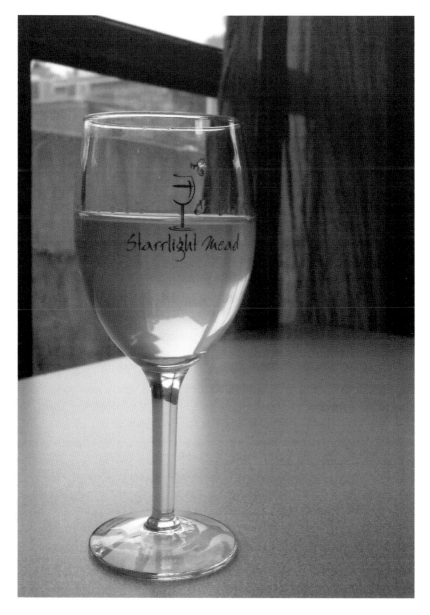

A glass of mead at Starrlight Meadery. *Photo from the author's collection.*

without the added stress of the process, which used to take at least a year to condition before drinking.

Ben Starr and his wife, Becky, are the owners of Starrlight Meadery in North Carolina. Ben was a beekeeper in Southern California at the very

The water tower at Starrlight Meadery. *Photo from the author's collection.*

early age of twelve. In later years, he tried mead at a renaissance fair for the first time, and it interested him. He moved to North Carolina in the early 2000s and started to make mead at home. In 2006, he and his wife won first place in the Mazer Cup Mead Competition in their submitted category. A few years later, in 2010, they opened the doors to their first

meadery. Ben also has a beehive on the meadery grounds that he and his son look after.

Years before the new mead movement, Vicky Rowe started the website Gotmead.com out of Raleigh, North Carolina. She got interested in mead after tasting it at renaissance fairs in the mid-'80s and has since grown a popular and busy web forum for mead enthusiasts to access information about recipes and discussion.

Martin Key and Justin Schoendorf opened the doors to Georgia's first meadery, Monks Mead, in Athens, Georgia. The Savannah Brewers League of Georgia is host to the annual Domras Cup, held every year since 1999. It started out as a "club-only" small competition and has since grown. The competition is named after Chuck Domras, a club member who passed away earlier that same year and was quite fond of mead. Entries are now received for the competition from all over the country. Savannah Bee Company has a mead-tasting bar at its flagship store in Savannah where customers can taste a variety of meads produced by several meaderies from around the country.

BEEKEEPER ASSOCIATIONS AND SALES OUTLETS

GEORGIA ASSOCIATIONS

BARTOW BEEKEEPERS ASSOCIATION
Contact: Bill Posey
Phone: (770) 386-3311
E-mail: billsbeefarm@yahoo.com

BEEKEEPERS CLUB OF GWINNETT COUNTY
Contact: Tommy Bailey
2285 Fortune Drive, Dacula, GA 30019
Phone: (678) 232-5401
E-mail: baileysbees@gmail.com

CHATTAHOOCHEE BEEKEEPERS
 ASSOCIATION
Contact: Jim Harris
34333 Pontiac Drive, Columbus, GA
 31907
Phone: (706) 563-4186
E-mail: hhonybee@bellsouth.net

CHEROKEE COUNTY BEE CLUB
www.cherokeebeeclub.com
Contact: Ryan A Sarks
1574 Old Canton Road, Ballground,
 GA 30107
Phone: (770) 735-2882
E-mail: beehavenapiaries@gmail.com

COASTAL EMPIRE BEEKEEPERS ASSOCIATION
www.cebeekeeping.com
Contact: Faith Jaudon
1049 Ralph Rahn Road, Rincon, GA
 31326
Phone: (912) 667-3272
E-mail: papacat33@comcast.cnet

COWETA BEEKEEPERS ASSOCIATION
www.cowetabeekeepers.org
Contact: Steve Page
180 Barrington Grange Drive,
 Sharpsburg, GA 30277
E-mail: steve@cowetahoney.com

EAST CENTRAL GEORGIA BEE CLUB
Contact: Edwin S. Stephens
522 Pine Needle Road, Waynesboro,
 GA 30830

EASTERN PIEDMONT BEEKEEPERS
 ASSOCIATION
Contact: Paul D. Smith
Phone: (706) 548-6296
E-mail: pauloralbie@charter.net

FORSYTH COUNTY BEEKEEPERS
 ASSOCIATION
Contact: Candy Bailey
Phone: (770) 530-6397
E-mail: baileybees@gmail.com

GEORGIA BEEKEEPERS ASSOCIATION
www.agr.state.ga.us
Contact: Virginia Webb
349 Gastley Road, Clarksville, GA
 30523
Phone: (706) 754-7062
E-mail: mtnhoney@windstream.com

HEART OF GEORGIA BEEKEEPERS
 ASSOCIATION
www.heartofgeorgiabeekeepers.
 blogspot.com
Contact: Steve Nofs
304 Woodmont Court, Macon, GA
 31216
Phone: (478) 396-0712
E-mail: steve@shamrockapiaries.com

HENRY COUNTY BEEKEEPERS
 ASSOCIATION
Contact: Tom Bonnell
95 Little Road, Hampton, GA 30228
Phone: (770) 473-5434
E-mail: hortpa@uga.edu

METRO ATLANTA BEEKEEPERS
www.metroatlantabeekeepers.org
Contact: Richard Kiefer
1820 East Stoneykirk Close, Atlanta,
 GA 30350
Phone: 770-668-0981
E-mail: rokmak@comcast.net

MOUNTAIN BEEKEEPERS ASSOCIATION
Contact: Glen Henderson
338 Epps Mountain Lane, Blairsville,
 GA 30512
Phone: 706-745-1795
E-mail: abletiner@aol.com

NORTHEAST MOUNTAIN BEEKEEPERS
 ASSOCIATION
Contact: Virginia Webb
349 Gastley Road, Clarksville, GA
 30523
Phone: (706) 754-7062
E-mail: mtnhoney@windstream.net

OGEECHEE AREA BEEKEEPERS
 ASSOCIATION
www.oabees.com
Contact: Rhett Kelley
Phone: (912) 685-6759
E-mail: rhettkelley77@yahoo.com

PAULDING COUNTY BEEKEEPERS
 ASSOCIATION
Contact: Sue McCleary
20 Pine Ridge Farm Drive, Dallas, GA
 30157
Phone: 678-925-1978
E-mail: suemccleary102@gmail.com

SOUTHEASTERN GEORGIA BEEKEEPERS
Contact: Ben Bruce
159 Homeplace Road, Homerville, GA
 31634
Phone: (912) 487-2001
E-mail: nuthoney@windstream.net

SOUTHWEST GEORGIA BEEKEEPERS
ASSOCIATION
Contact: Sonny Swords
5 28ᵗʰ Avenue NW, Moultrie, GA 31768
Phone: (229) 941-5752

TARA BEEKEEPERS ASSOCIATION
www.tarabeekeepers.org
Contact: Gary Cooke
1820 Old Conyers Road, Stockbridge,
 GA 30281
Phone: (678) 410-2087
E-mail: Lcooke77@aol.com

GEORGIA LOCATIONS PERMITTED TO SELL BEES

BLUE RIDGE HONEY CO.
PO Box 15, Lakemont, GA 30552
(706) 782-6722

DIXIE BEE SUPPLY
Lula, GA (706) 677-3502

DREW APIARIES
Hahira, GA (800) 831-6705

GARDNER'S APIARIES/SPELL BEE LLC
510 Patterson Road, Baxley, GA 31513
(912) 367-9352

GEORGIA BEES
Milledgeville, GA (478) 452-2337

H&R APIARIES
2700 South Macon Street Extension,
Jessup, GA 31545 (912) 427-7311

HARDEMAN APIARIES
PO Box 214, Mount Vernon, GA
30445 (912) 583-2710

HONEY-N-ME BEE FARM
Covington, GA (770) 833-1235

JJ'S HONEY
5748 Chancey Road, Patterson, GA
31557 (912) 647-3726

JOHN PLUTA HONEY & BEES
Milledgeville, GA (478) 452-2337

DONALD KUCHENMEISTER
Lula, GA (706) 677-3502

M&N APIARY
264 Tillman Anderson Road, Jesup,
GA 31545 (912) 294-6123

PLANTATION BEE CO.
St. Simons Island, GA (912) 634-1884

PURVIS BROTHERS APIARIES
Blairsville, GA (706) 781-3128

ROSSMAN APIARIES INC.
3364-A Georgia Highway 33 North,
Moultrie, GA 31768 (229) 985-7200

SHUMEN'S APIARIES
Baxley, GA (912) 367-2243

SPELL BEE CO.
Baxley, GA (912) 367-9352

SWORDS APIARIES
Moultrie, GA (912) 985-9725

WILBANKS APIARIES INC.
Claxton, GA (912) 739-4820

SOUTH CAROLINA ASSOCIATIONS

AIKEN BEEKEEPERS ASSOCIATION
Contact: Allen Johnson
744 Tinker Creek Road, Williston, SC
 29853
Phone: (803) 266-5162
E-mail: johnson_9555@msn.com

BLACKWATER BEEKEEPERS ASSOCIATION
www.Blackwaterbeekeepers.org
Contact: Jerry Dickenson
3860 Second Loop Road, Conway, SC
 29526
Phone: (843) 365-4513
E-mail: jerryd15@sccoast.net

CALHOUN AREA BEEKEEPERS
 ASSOCIATION
Contact: Charles Davis
112 Courthouse Annex, St. Matthew,
 SC 29135

CHARLESTON AREA BEEKEEPERS
 ASSOCIATION
Contact: Larry Haigh
1318 Bluebird Drive, Mount Pleasant,
 SC 29464
Phone: (843) 849-5095
E-mail: charlestonbees@gmail.com

CHEROKEE COUNTY BEEKEEPERS
 ASSOCIATION
Contact: Alama Willingham
PO Box 700, Gaffney, SC 29342

EDISTO BEEKEEPERS ASSOCIATION
Contact: Henry Chassereau
1150 Sash Lane, Ehrhardt, SC 29081
Phone: (803) 267-5075

LAKELAND BEEKEEPERS ASSOCIATION
Contact: Ron Richards
1283 Southview Road, Laurens, SC
 28360
Phone: (864) 682-5440
E-mail: RERCER@aol.com

LOW COUNTRY BEEKEEPERS ASSOCIATION
Contact: Archie Biering
1081 Holly Ridge Lane, Cottageville,
 SC 29435
Phone: (843) 835-5912

MID-STATE BEEKEEPERS ASSOCIATION
www.scmidstatebeekeepers.org
Contact: Wesley Bommer
403 Edisto Lake Road, Wagener, SC
 29164
Phone: (803) 564-6487
E-mail: Midstatebees@yahoo.com

OCONEE COUNTY BEEKEEPERS
 ASSOCIATION
Contact: W.H. Knight
250 Whitmire Church Road, Tamassee,
 SC 29686
Phone: (864) 638-7321
E-mail: knyte@innova.net

PEE DEE BEEKEEPERS ASSOCIATION
Contact: Eric Mills
861 Andrews Mill Road, Timmonsville,
 SC 29161
E-mail: ccartrette@wmconnect.com

PICKENS COUNTY BEEKEEPERS
 ASSOCIATION
Contact: Dwight Porter
852 Earls Bridge Road, Easley, SC
 29640
Phone: (864) 593-1535
E-mail: pcbeekeepers@yahoo.com

PIEDMONT BEEKEEPERS ASSOCIATION
www.pba.beebuzz.org
Contact: Steve Genta
3450 Fork Shoals Road, Simpsonville,
 SC 29680
Phone: (864) 243-9013
E-mail: scbeeman@aol.com

SOUTH CAROLINA STATE BEEKEEPERS
 ASSOCIATION
Contact: Don VanBorsch
407 Old Plantation Drive, West
 Columbia, SC 29172
Phone: (803) 446-1639
E-mail: dvanborsch@hotmail.com

SUMTER COUNTY BEEKEEPERS
 ASSOCIATION
Contact: F.L. Newman
1030 State Street, Sumter, SC 29150

WESTERN PIEDMONT BEEKEEPERS
Contact: Larry Williams
501 Youth Center Road, Belton, SC
 29627
Phone: (864) 338-5470

YORK COUNTY BEEKEEPERS
 ASSOCIATION
Contact: Carroll Moore
197 Arrow Road, York, SC 29745
Phone: (803) 684-4369
Cell: (803) 984-7740

SOUTH CAROLINA LOCATIONS PERMITTED TO SELL BEES

BEE CITY HONEYBEE FARM
Field trips scheduled on weekdays all
year. Honey, pollen, wax and many
items available in the store. Petting zoo,
café and a nature center to explore.
1066 Holly Ridge Lane, Cottageville,
 SC 29435
Phone: (843) 835-5912

BEE WELL HONEY COMPANY
Bottling and selling honey/retail, honey
producer, beeswax and pollen, honey
bee breeder, queens for sale, honey bee
education, beekeeping supplies
www.beewellhoneyfarm.com
Owner Operator: Kerry Owens

205 Wade Hampton Avenue, Pickens, SC
338 Brevard Street, Brevard, NC
109 Trade Street, Simponsville, SC
1354 Rutherford Road, Greenville, SC
Phone: (864) 898-5122
E-mail: BeeWellHoney@bellsouth.net

CAROLINA HONEYBEES
Selling raw local honey, creamed honey,
beeswax candles, goat milk and honey soap
www.CarolinaHoneybees.com
Owner Operator: Charlotte Anderson
Pickens, SC 29671
Phone: 864-878-8593
E-mail: cdanderson1@charter.net

DIXIE BEE SUPPLY
www.shopdixiebee.com
2672 Pageland Highway, Lancaster, SC
29720
Store phone: (803) 285-BEES (2337)
Cellphone: (803) 577-7871
E-mail: dixiebeestore@gmail.com

MAMA BEEHIVE HONEY FARM
Selling honey, beeswax candles, honey/
beeswax health products
www.MamaBeehive.com
Owner Operator: Sally Adams
E-mail: MamaBeehive@yahoo.com

NORTH CAROLINA ASSOCIATIONS

ALAMANCE COUNTY BEEKEEPERS
ASSOCIATION
Contact: Scott Jewill
PO Box 4156, Glen Raven, NC 27215
Phone: (336) 421-0034

ANSON COUNTY BEEKEEPERS ASSOCIATION
Contact: Harvey Tucker
152 Moores Lake Road, Wadesboro,
NC 28170
Phone: (704) 694-3325

BEEKEEPERS OF THE ALBEMARLE
ASSOCIATION
www.beekeepersof theablermarle.com
Contact: Paul Newbold
759 Chapanoke Road, Hertford, NC
27944
Phone: (252) 264-0245
E-mail: beefarmer1349@gmail.com

BEEKEEPERS OF WILKES COUNTY
Contact: Tony Benge
212 Mountain Top Road, Thurmond,
NC 28683
Phone: (336) 874-2260

BRUNSWICK COUNTY BEEKEEPERS
ASSOCIATION
Contact: James Smith
600 Oakwood Drive Southwest, Supply,
NC 28462
Phone: (910) 842-4731

BUNCOMBE COUNTY BEEKEEPERS
www.wncbees.org
c/o NC Coop Extension
94 Coxe Avenue, Asheville, NC 28805
Phone: (828) 252-5522

BURKE COUNTY BEEKEEPERS
ASSOCIATION
Contact: Stanley Carter
PO Box 71, Morganton, NC 28680
Phone: (828) 433-6057

CABARRUS COUNTY BEEKEEPERS
ASSOCIATION
Contact: Fay Griffin
5175 U.S. Highway 601 South,
Concord, NC 28025
Phone: (704) 782-8162
E-mail: fgriffin4@carolina.rr.com

CALDWELL COUNTY BEEKEEPERS
ASSOCIATION
Contact: Patricia Barry
2391 Trail Lane, Lenoir, NC 28645
E-mail: BarryPe@aol.com

CATAWBA VALLEY BEEKEEPERS
ASSOCIATION
Contact: Alton L. Johnson
5930 Alley Road, Catawba, NC 28609
Phone: (828) 241-2923
E-mail: bestbeekeeper@aol.com

CHATHAM COUNTY BEEKEEPERS
ASSOCIATION
Contact: Michael Almond
PO Box 791, Pittsboro, NC 27312

COASTAL PLAIN BEEKEEPERS
ASSOCIATION
Contact: Bob Filbrun
PO Box 129, Tarboro, NC 27886
Phone: (252) 641-7815
E-mail: bob_filburn@ncsu.edu

COLUMBUS COUNTY BEEKEEPERS
ASSOCIATION
Contact: Robert Bass
5201 Peacock Road, Whiteville, NC
 28472
Phone: (910) 642-3562

CRAVEN-PAMLICO BEEKEEPERS
ASSOCIATION
Contact: Kirk Williams
135 Ducks Way, New Bern, NC 28562
E-mail: fkwilliams@always-online.com

CRYSTAL COAST BEEKEEPERS ASSOCIATION
Contact: Ann Edwards
Phone: (252) 222-6259

DAVIE COUNTY BEEKEEPERS ASSOCIATION
Contact: Susan Fariss
142 Cemetery Road, Mocksville, NC
 27028
Phone: (336) 998-2975
E-ail: SusanFariss@
 PeacefulValleyHoney.com

DURHAM COUNTY BEEKEEPERS
ASSOCIATION
Contact: John Wallace
5309 Summer Rose Lane, Durham,
 NC 27703
Phone: (919) 475-2799
E-mail: jwallace@hotmail.com

FORSYTH COUNTY BEEKEEPERS
ASSOCIATION
Contact: Tommy Shutt
865 McGreggor Drive, Winston-Salem,
 NC 27103

GASTON COUNTY BEEKEEPERS
ASSOCIATION
Contact: Jack Page
220 Lakeview Drive, Belmont, NC
 28012

GRANVILLE COUNTY BEEKEEPERS
ASSOCIATION
Contact: Will Hicks
327 John Allen Road, Roxboro, NC
 27573

GUILFORD COUNTY BEEKEEPERS
ASSOCIATION
Contact: Kurt Bower
5430 Amick Road, Julian, NC 28283
Phone: (336) 697-2811
E-mail: microweld66@yahoo.com

HAYWOOD COUNTY BEEKEEPERS
ASSOCIATION
www.hcbees.org
c/o Haywood County Extension Center
589 Raccoon Road, Waynesville, NC
 28786
Phone: (828) 452-2741

HENDERSON COUNTY BEEKEEPERS
ASSOCIATION
Contact: Marvin Owings
740 Glover Street, Hendersonville, NC
 28792
Phone: (828) 697-4891
E-mail: marvin_owings@ncsu.edu

IREDELL COUNTY BEEKEEPERS
 ASSOCIATION
Contact: Scott Wheeler
318 Walton Drive, Statesville, NC
 28625
Phone: (704) 873-1122

MACON COUNTY BEEKEEPERS
 ASSOCIATION
Contact: Janet Hill
249 Bates Branch Road, Franklin, NC
 28734
Phone: (828) 369-9819
E-mail: janet28734@gmail.com

MADISON COUNTY BEEKEEPERS
 ASSOCIATION
Contact: Dewain Mackey
1150 Fred Holcombe Road, Mars Hill,
 NC 28754
Phone: (828) 689-5977
E-mail: Mackeyfarms@Juno.com

McDOWELL COUNTY HONEY BEES
Contact: Ray L. Revis
PO Box 2520, Marion, NC 28752
Phone: (828) 652-5463
Fax: (828) 659-9801
E-mail: revisinc@wnconline.net

MECKLENBURG BEEKEEPERS ASSOCIATION
www.meckbees.org
Contact: Libby Mack
121 Hermitage Road, Charlotte, NC
 28207
Phone: (704) 358-8075
E-mail: libbymack@earthlink.net

MOORE COUNTY BEEKEEPERS
 ASSOCIATION
Contact: Sanford Toole
90 Sawmill Road West, Pinehurst, NC
 28374
Phone: (910) 295-6676
E-mail: stoole@nc.rr.com

MOUNTAIN BEEKEEPERS ASSOCIATION
Contact: Larry Sams
158 Needmore Drive, Hayesville, NC
 28904
Phone: (828) 389-3881
E-mail: samsl@verizon.net

NORTH CAROLINA COOPERATIVE
 EXTENSION
Contact: Kenneth Bailey
Department of Agriculture, 301 East
 Mountain Drive, Fayetteville, NC
 28306
Phone: (910) 321-6871

NORTH CAROLINA STATE BEEKEEPERS
 ASSOCIATION
www.ncbeekeepers.org
Contact: Paul L. Madren
329 Laurel Street, Mount Airy, NC
 27030
Phone: (336) 786-4848
Fax: (336) 376-9109
E-mail: plmadre@mindspring.com

ORANGE COUNTY BEEKEEPERS
 ASSOCIATION
www.theocba.org
Contact: Jack Tapp
1201 New Hope Church Road, Chapel
 Hill, NC 27516
Phone: (919) 942-2006
Fax: (919) 942-1069
E-mail: busybeeofnc@bellsouth.net

PERSON COUNTY BEEKEEPERS
 ASSOCIATION
Contact: Tim Gentry
13410 Virgilina Road, Roxboro, NC
 27574

RANDOLPH COUNTY BEEKEEPERS
ASSOCIATION
Contact: Jerry Isley
1276 Kennedy Farm Road, Tomasville,
NC 27360
Phone: (336) 472-6325

RICHMOND COUNTY BEEKEEPERS
ASSOCIATION
Contact: Wayne Sanders
PO Box 629, Richmond, NC 28338

ROBESON COUNTY BEEKEEPERS
ASSOCIATION
Contact: M. Brewington
PO Box 2168, Pembroke, NC 28372

ROCKINGHAM COUNTY BEEKEEPERS
ASSOCIATION
www.rockinghambeekeepers.org
Contact: Lenzie D Kinyon
PO Box 4, Stoneville, NC 27048
Phone: (336) 623-8059
E-mail: lkinyon@
 rockinghambeekeepers.org

ROWAN COUNTY BEEKEEPERS
ASSOCIATION
www.ncbeekeepers.org
Contact: Marcel Renn
2495 Faith Road, Salisburg, NC 28146
Phone: (704) 637-8931
E-mail: marcelrenn@hotmail.com

RUTHERFORD COUNTY BEEKEEPERS
ASSOCIATION
www.freewebs.com/
 rutherfordbeekeepers
Contact: Jeanne Price
182 Elizabeth Avenue, Forest City, NC
28043
Phone: (828) 247-1640
E-mail: jeanne_price@bellsouth.net

SOUTHWEST PIEDMONT BEEKEEPERS—
MARTINSVILLE
Contact: Frank Wyatt
PO Box 4563, Eden, NC 27289
Phone: (336) 635-5821
E-mail: wyfgrp@netpath-rc.net

SOUTHWEST VIRGINIA BEEKEEPERS
ASSOCIATION—MARTINSVILLE
Contact: Gail Keaton
2325 Trent Hill Drive, Bassett, NC
24055
Phone: (276) 629-7275

STANLEY COUNTY BEEKEEPERS
ASSOCIATION
Contact: Mike Barbee
10049 Sedgefield Circle, Starfield, NC
28163
Phone: (704) 888-2663
E-mail: pmbarbee@yahoo.com

SURRY COUNTY BEEKEEPERS
ASSOCIATION
Contact: Hampton Beamer
2475 West Pine Street, Mount Airy, NC
27030
Phone: (336) 786-6467

TIDEWATER BEEKEEPERS ASSOCIATION
www.tidewaterbeekeepers.net
Contact: Carol Keenoy
121 Wade Cove Lane, Knotts Island,
NC 27950-9619
Phone: (252) 429-3134
E-mail: beelady1952@aol.com

TOE-CANE BEEKEEPERS ASSOCIATION
Contact: Stinson McCroskey
605 Raven Rock Lane, Micaville, NC
28755
Phone: (828) 675-4927

TRANSYLVANIA COUNTY BEEKEEPERS
ASSOCIATION
Contact: Rick Queen
305 Davidson River Road, Pisgah
 Forest, NC 28768
Phone: (828) 884-5121

UNION COUNTY BEEKEEPERS
ASSOCIATION
www.beeguys.com
Contact: Jeff Knight
5903 W.M. Griffin Road, Monroe, NC
 28112
Phone: (704) 764-3731
E-mail: knightja@msn.com

WAKE COUNTY BEEKEEPERS
ASSOCIATION
www.NCneighbors.com
Contact: Rick Barbour
3440 Neuma Drive, Zebulon, NC
 27597
Phone: (919) 269-0108
E-mail: rickybarbour@nc.rr.com

WATAUGA COUNTY BEEKEEPERS
ASSOCIATION
www.DavieBeekeepers.org
Contact: Susan Bragg
195 Wintergreen Lane, Boone, NC
 28607

NORTH CAROLINA LOCATIONS PERMITTED TO SELL BEES

ALBEMARLE BEE CO.
32586B Austin Road, New London,
 NC 28127 (704) 463-1233

BAILEY BEE SUPPLY
359 Ja-Max Drive, Hillsborough, NC
 27278 (919) 241-4236

BAILEY BEE SUPPLY
1724 South Saunders Street, Raleigh,
 NC 27603 (919) 977-0901

ROBERT E. BAUCOM
2518 Hamiltons Road, Marshville, NC
 28103 (704) 624-5116

BEECH MOUNTAIN
2775 Beech Mountain Road, Elk Park,
 NC 28622 (828) 733-4525

BEE DELIGHT HONEY FARM
510 Flower House Loop, Troutman,
 NC 28166 (704) 450-1703

BELL'S BEES
2809 Campbell Road, Raleigh, NC
 27606 (919) 417-1506

BETSEY'S BEES
1226 Mount Olivet Church Road,
 Franklinton, NC 27525 (919) 495-1450

BIG OAK BEE FARM
2633 Branch Road, Raleigh, NC 27610
 (919) 272-4450

BLANTON APIARIES
1844 Back Creek Court, Asheboro, NC
 27205 (336) 683-7390

MIKE BOURN
1104 Arbor Drive, China Grove, NC
 28023 (704) 857-7699

BILLY R. BOYD
5803 Old Monroe Road, Indian Trail,
 NC 28079 (704) 821-7310

DAVID BRIDGERS
118 Wellington Drive, Wilmington, NC
28411 (910) 686-1947

BRIDGES BEE SUPPLIES
121 Parkdale Circle, Kings Mountain,
NC 28086 (704) 739-6435

BRUSHY MOUNTAIN BEE FARM INC.
610 Bethany Church Road, Moravian
Falls, NC 28654 (336) 921-3640

JOEY LEE BULLIN
2633 Woodruff Road, Boonville, NC
27011 (336) 244-1415

BUSY BEE APIARIES
1201 New Hope Church Road, Chapel
Hill, NC 27516 (919) 904-7128/
(919) 516-6621

C&L BEE FARM
795 Crawford Road, Salisbury, NC
28146 (704) 640-8108

MARGARET CANTERBURY
3336 Startown Road, Newton, NC
28658 (828) 855-6942

CAROLINA BEE COMPANY
237 Jason Way, Youngsville, NC 27596
(919) 728-0827

CARL CHESICK
22 Cedar Hill Road, Asheville, NC
28806 (828) 779-7047

ROBERT M. DENNIS
1040 High Meadows Drive, Concord,
NC 28025 (704) 721-5630

BOB DOTY
6325 Stirewalt Road, Kannapolis, NC
28081 (704) 934-2640

TODD EURY
1753 Liberty Ridge Road, Concord,
NC 28025 (704) 791-3015

BRYAN FISHER
712 Deaton Street, Kannapolis, NC
28081 (980) 521-8642

SAM FROGGE
232 Antietam Road, Statesville, NC
28625 (704) 585-2004/(704) 929-6868

TIMOTHY A. FRYE
PO Box 761, Liberty, NC 27298
(336) 549-7358

G&S BEEFARM
900 Honeysuckle Lane, Albemarle, NC
28001 (704) 982-0698

GOMMIN ACRES FARM
1945 Davis Mountain Road,
Hendersonville, NC 28739
(828) 693-1966

GREG'S HONEY HIVE
125 Yamasee Road, Waxhaw, NC
28173 (704) 400-8965

WAYNE HANSEN
8004 Southway Road, Charlotte, NC
28215 (704) 536-4805

HAPPY BEES APIARY
347 South Wharton Station Road,
Washington, NC 27889
(252) 945-1730

RALPH HARLAN
1295 Brevard Place Road, Iron Station,
NC 28080 (704) 807-6207

HARRIS APIARIES
10055 Highway 53 West, White Oak,
NC 28399 (910) 988-6227

JEFFREY C. HINSON
16331 Philadelphia Church Road,
Oakboro, NC 28129 (704) 438-8760

HOLBERT BEE SUPPLY
PO Box 217, Saluda, NC 28773
(828) 749-2337

TIMOTHY R. HOLT
132 Holt's Lane, Siloam, NC 27047
(336) 710-4904

JIM'S BEES
1106 Mohawk Avenue, Fayetteville, NC
28303 (910) 273-2782

JESSE M. JOSEY
7090 Wishing Well Road, Pfafftown,
NC 27040 (336) 407-1553

RON KINNEY
3970 Tennyson Court, Concord, NC
28027 (704) 453-1131

KENNETH G. KNIGHT
3259 River Forks Road, Sanford, NC
27330 (919) 545-1166

DANNY H. LASHUS
556 Stephens Road, Providence, NC
27315 (434) 710-4344

LEE'S BEES INC.
1818 Saddle Club Road, Mebane, NC
27302 (919) 949-6140

DAVID LINK
157 Crepe Myrtle Circle, Winston
Salem, NC 27106 (336) 251-3427

RAYON LOCKLEAR
2883 South Duffie Road, Red Springs,
NC 28377 (910) 843-5561

GERRY AND LIBBY MACK
121 Hermitage Road, Charlotte, NC
28207 (704) 358-8075

GEORGE MACKEL
298 Timbuktu Road, Sylva, NC 28779
(828) 332-0576

M&B HONEY FARM
2265 Baptist Grove Road, Fuquay
Varina, NC 27526 (770) 654-7535

McCOY FEED & FARM SUPPLY INC.
4420 Highway 24-27 East, Midland,
NC 28107 (704) 888-2298

CHRIS MENDENHALL
5703 Midway School Road,
Thomasville, NC 27360
(336) 442-9835

FRED MERRIAM
221 Bryson Drive, Hamlet, NC 28345
(480) 209-2098

MILLER BEE SUPPLY, INC.
496 Yellow Banks Road, North
Wilkesboro, NC 28659 (336) 670-2249

1 SWEET WINGS HONEY BEE FARM
2014 Coddle Creek Highway,
Mooresville, NC 28115 (704) 904-6725

ORR BEE SUPPLY
323 Morris Hollow Road, Old Fort,
NC 28762 (828) 581-4494

GEORGE C. PAGE
2686 Piney Grove Road, Kernersville,
NC 27284 (336) 317-4681

PENNY APIARIES
501 Penny Road, Beulaville, NC 28518
(910) 290-4186/(910) 290-2663

PLANK ROAD APIARY
3350 South Plank Road, Sanford, NC
27330 (919) 776-9517

QUEEN BEE HONEY FARM, LLC
119 Terry Springs Lane, Statesville, NC
28677 (704) 682-4018

CHARLES D. REVIS
921 East Court Street, Marion, NC
28752 (828) 925-1430

REVIS RUSSIAN APIARIES
PO Box 2520, Marion, NC 28752
(828) 652-3524

JEFF RITCHIE
3901 Piney Road, Morganton, NC
28655 (828) 438-1720

SAPONY CREEK APIARIES
3542 Collie Road, Nashville, NC 27856
(252) 443-6471

BILLY SEARCY
PO Box 451, Columbus, NC 28722
(828) 817-0266

7 STANDS BEE FARM
1885 Middle Fork Road, Hays, NC
28635 (336) 957-4744

SHAKEN CREEK FARMS, INC.
7429 Old Maple Hill Road, Burgaw,
NC 28425 (910) 540-4611

SILVER SPOON APIARIES, INC.
PO Box 4486, Wilmington, NC 28406
(910) 352-7868

DONNIE SMITH
599 John Russell Road, Raeford, NC
28376 (910) 875-5640

SPRING BANK BEE FARM
298 Spring Bank Road, Goldsboro, NC
27534 (919) 778-0210

SWEET BETSY FARM
3947 Mudcut Road, Marion, NC
28752 (828) 724-4444

TATE'S APIARIES
2241 Union Cross Road, Winston-
Salem, NC 27107 (336) 788-4554

CALVIN B. TERRY JR.
PO Box 702/105 Johnson Street, Vass,
NC 28394 (910) 528-1153

RICK TINDAL
24164 Cedar Ridge Lane, Albemarle,
NC 28001 (704) 985-6236

TRIAD BEE SUPPLY
4062 Evergreen Drive, Trinity, NC
27370 (336) 475-5137

TRIPLE J FARMS
595 Duke Whittaker Road, Mocksville,
NC 27028 (336) 492-7564

TRIPLE S BEE FARM
270 Farin Ward Road, Stella, NC
28582 (910) 787-2577

WILLIAM TRIVETTE
10500 McFarland Road, Laurel Hill,
NC 28351 (910) 610-3369

CHARLES DEAN TRULL JR.
1428 Trull Place, Monroe, NC 28110
(704) 201-3520

JEREMY TYSON
742 Eagle Falls Road, Madison, NC
27025 (336) 453-1281

VALLE CRUCIS BEE COMPANY, LLC
488 Tom Ward Road, Sugar Grove,
 NC 28679 (828) 773-7081

VETHEALTH CONCEPTS INC.
PO Box 102, Richlands, NC 28574
 (910) 330-0481

WAGRAM APIARY
24560 McGill Street, Wagram, NC
 28396 (910) 318-1202

ROGER WALKER
13965 U.S. 64 Alternate Highway, West
 Rocky Mount, NC 27801
(252) 442-4065

MICHAEL WALLACE
11460 Peach Orchard Road,
 Harrisburg, NC 28075
(704) 737-3947

KATHY WEBB
308 Webb Farm Road, Salisbury, NC
 28147 (704) 637-8043

WG BEE FARM
PO Box 4563, Eden, NC 27289
 (336) 635-5821

ED AND RUTH WHITLEY
1247 Salisbury Avenue, Albemarle, NC
 28001 (704) 982-3136

WILD MOUNTAIN APIARIES
875 Will Arrington Road, Marshall,
 NC 28753 (828) 689-4095

RICHARD JOHN WRIGHT
134 Maggie Drive, Mount Gilead, NC
 27306 (910) 439-1879

BIBLIOGRAPHY

BOOKS AND PERIODICALS

Abramson, Rudy, and Jean Haskell, eds. Encyclopedia of Appalachia. Chattanooga: University of Tennessee Press, 2006.

Bishop, Holley. *Robbing the Bees*. New York: Free Press, 2005.

Dixie Beekeeper, 1922.

Favretti, Rudy, and Joy Favretti. *For Every House a Garden*. Lebanon, NH: University Press of New England, 1990.

Grizzard, Frank E. *George Washington: A Biographical Companion*. Santa Barbara, CA: ABC-CLIO, Inc., 2002.

Hawkins, Kennith. *Beekeeping in the South*. Hamilton, IL: American Bee Journal, 1920.

Horn, Tammy. *Bees in America: How the Honey Bee Shaped a Nation*. Lexington: University Press of Kentucky, 2005.

Magill, Mark. *The Way to Bee: Meditation and the Art of Beekeeping*. Guilford, CT: Lyons Press, 2011.

Miner, T.B. *The American Bee Keeper's Manual*. New York, 1851.

Mingo, Jack. *Bees Make the Best Pets*. San Francisco: Conari Press, 2013.

North Carolina Beekeeper, issues 1–5.

Progressive Farmer, August 30, 1904.

Ransome, Hilda M. *The Sacred Bee in Ancient Times and Folklore*. Mineola, NY: Dover Publications, 2004.

Scott, Harry Eldon. *Honey Bees in North Carolina*. Raleigh: N.C. Agricultural Extension Service, 1973.

Transactions of the Georgia State Agricultural Society, 1878.

Washington Public Documents 2 (1920).

Wilder, J.J. *System of Beekeeping*. N.p., 1927.

ONLINE SOURCES

American Bee Journal. "The Story of the American Bee Journal." www.americanbeejournal.com/site/epage/79325_828.htm.

———— 58 (1918): 381. books.google.com/books?id=oJYcAQAAMAAJ&pg=PA3 81&dq.

———— 59 (1919): 158. books.google.com/books?id=Orc5AQAAMAAJ&pg=PA1 58&dq.

American Beekeeper 13–14 (1903): 120. books.google.com/books?id= GbpJAAAAYAAJ&num=19.

American Civil War. "Hattie Brunson/Mrs. C.G. Richardson." www.americancivilwar.com/women/cr.html.

Clemson Cooperative Extension. "The Africanized Honey Bee in the United States." www.clemson.edu/extension/beekeepers/factsheets/africanized_honey_bee_in_the_united_states.html.

————. "Smith-Lever Act." www.clemson.edu/extension/100/smith-lever-act-1914.html.

"Colonies of Bees and Honey Collected." www.agcensus.usda.gov/Publications/2007/ Full_Report/Volume_1,_Chapter_2_US_State_Level/st99_2_021_021.pdf.

Delaney, Debbie. "History of the Honey Bee in the U.S." www.savethehives.com/ test_fbp/history.html.

Douglas, Anna. "Taste for Honey Turns into Award-Winning Career for Clover Woman." *Herald Online*, August 5, 2013. www.heraldonline.com/2013/08/05/5087048/ taste-for-honey-turns-into-award.html#storylink=cpy.

Hahira Honeybee Festival. www.hahirahoneybeefestivalinc.com.

Hebrew University of Jerusalem. "First Beehives in Ancient Near East Discovered." *ScienceDaily* 5 (September 2007). www.sciencedaily.com/ releases/2007/09/070904114558.htm.

Johnson, Renee. "Honey Bee Colony Collapse Disorder." Congressional Research Service. January 7, 2010. fas.org/sgp/crs/misc/RL33938.pdf.

Oertel, Everett. "History of Beekeeping in the United States." *Beekeeping in the United States Agriculture Handbook* 335 (October 1980). www.beesource.com/resources/ usda/history-of-beekeeping-in-the-united-states.

Thompson, Isaac. "Honey: World Production, Top Exporters, Top Importers, and United States Imports by Country." *World Trade Daily*, July 28, 2012. worldtradedaily.com/2012/07/28/honey-world-production-top-exporters-top-importers-and-untied-states-imports-by-country.

State Symbols USA. "Georgia State Insect." www.statesymbolsusa.org/Georgia/ insect_honeybee.html.

Success in Bee-Culture. "Patents—Are They Necessary?" archive.org/stream/ successinbeecult00hedd#page/72/mode/2up.

Wikipedia. "Hand-pollination." en.wikipedia.org/wiki/Hand-pollination.

————. "Honey." en.wikipedia.org/wiki/Honey.

INTERVIEWS

Biering, Scott and Archie, owners of Bee City in Cottageville, SC. September 2014.

Haigh, Larry, co-founder of CABA (Charleston Area Beekeepers Association). September 2014.

Hoffman, Gloria, USDA, telephone interview. August 2014.

Slick, Devorah, e-mail correspondence. November 2014.

INDEX

ABOUT THE AUTHOR

April Aldrich, born in Greenville, South Carolina, but raised in Southern California, has returned to her roots in Summerville, South Carolina, where she resides with her family, two dogs and thousands of honey bees. She says her love for bees started when she learned about the medicinal uses of honey at a very early age. After graduating from nursing school, she put her focus on holistic health and alternative medicine. "The hive became a sort of backyard medicine cabinet," she says. An avid home brewer and beekeeper, she decided in 2007 to join the two passions and make mead. She now moonlights her own company, Must Bee Mead, a boxed kit to make a one-gallon batch of mead at home. Mead was once considered a medicinal elixir. It's what our ancestors drank before beer and wine was around, and to Aldrich, "that's cool." You can find her at www.mustbeemead.com.

ABOUT THE PHOTOGRAPHER

By day, Chrys Rynearson is the knowledge management (KM) lead for Space and Naval Warfare Systems Center (SPAWAR), but by night (and on weekends), he operates Exposur3, LLC as a freelance photographer and web developer, which he jokingly describes as "a much-needed creative outlet after working a less than creative government job." A photographer since 2002, he's worked for various clients such as the International Sake Institute, Google, *CHARLIE* magazine, The History Press, *Charleston City Paper*, *BeerAdvocate* magazine and more. More of his work can be seen on exposur3. com or at flickr.com/chrys.